PARANORMAL
CARDIFF

MARK REES

AMBERLEY

First published 2023

Amberley Publishing
The Hill, Stroud
Gloucestershire, GL5 4EP

www.amberley-books.com

British Library Cataloguing in Publication Data.
A catalogue record for this book is available from the British Library.

ISBN 978 1398 1 1475 3 (print)
ISBN 978 1398 1 1476 0 (ebook)

Origination by Amberley Publishing.
Printed in Great Britain.

Contents

Introduction

When the American folklorist Wirt Sikes was appointed US consul at Cardiff in the late Victorian era, little could he have known that he would be arriving in the city-to-be during one of its greatest periods of change. The native New Yorker would spend several years gathering ghost stories from across Wales, learning a little of the 'musical' language and raising a few glasses of *cwrw da* – good beer – along the way. In his temporary hometown, he visited Cardiff Castle when it was still the residence of the 3rd Marquess of Bute, and watched on as Lady Bute opened yet another part of the thriving docklands area. He wrote that 'the handsome sea-port' does not 'owe its importance to the ancient ruins which besprinkle Glamorganshire', but to the fact that it traded with the outside world from these ever-expanding docks. Sikes left Cardiff with the impression that it was a modern city that didn't dwell on past glories, and this is an impression that still runs true today. For while the docks that Sikes watched blossoming have since been redeveloped beyond recognition, if we were to walk around cosmopolitan Cardiff Bay today and gaze out over the same waters, while it

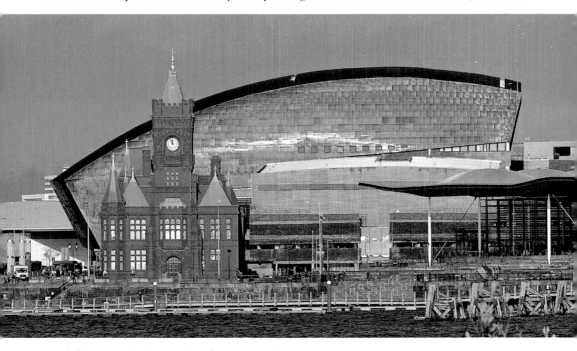

Cardiff Bay. (Richard Szwejkowski, CC BY-SA 2.0)

might be the Senedd behind us, or some giant fairground wheel, the sentiment remains the same: Cardiff is a city that looks to the future.

Which brings us to the ghost stories. Because a journey through Cardiff's haunted history is also a journey through the history of the city itself, as reflected in the five chapters of this book. We begin by exploring the legacy of the Bute family, who transformed the docks and established some of Cardiff's most well-known—and supposedly most haunted—landmarks. We then turn our attention to earlier accounts of paranormal activity, as collected by folklorists like Sikes. While other parts of Wales might be blessed with an embarrassment of Arthurian legends and whimsical fairy folk, the capital is a place of darker tales featuring death omens and devils. In fact, Cardiff excels in what might be described as the more chilling cases of supernatural activity.

The third and fourth chapters examine the industrial terrors that emerged as the population boomed during the Victorian and Edwardian eras. This period has been labelled the 'golden age' of ghosts in Britain, and that was certainly the case in Cardiff where terrifying accounts of pesky poltergeists and phantom ladies were never far from the headlines. Communicating with the dead was also a popular pastime, with several prominent mediums and celebrities participating in public and private séances. One such gathering became known as 'Cardiff's famous séance' and included guest of honour Sir Arthur Conan Doyle, the creator of Sherlock Holmes.

Finally, following Cardiff's elevation to city status in 1905, the last chapter brings us up to the modern day with reports of eerie encounters from recent memory. They include arguably the most high-profile haunting in the city's history which spanned more than a decade and baffled the experts, the wonderfully named Pete the Polt. While the case was never conclusively proven or disproven, it serves as a fascinating example of how a ghostly yarn can grip the collective imagination.

I hope you enjoy this tour through Cardiff's paranormal past, and I hope that maybe it will inspire you to look at what might be a very familiar city in a new light. A visit to National Museum Cardiff, Roath Park, Wales Millennium Centre or Castell Coch is always a good idea, and if you happen to feel a chill running up your spine at the same time after reading this book, well, that's just an added bonus.

Until next time, *nos da*!

 Mark Rees, 2022

A Haunted Legacy

Much of Cardiff, as we know it today, is the vision of a single family. From the turn of the nineteenth century, successive Marquesses of Bute, from their seat on the Isle of Bute in Scotland, transformed a Welsh town into a bustling capital of industry. They created the docks from which Wales would trade with the world, and their vast wealth converted crumbling castles into fairy-tale fortresses. While this might be common knowledge to many people with a passing interest in the city's history, what is less well known is that one Lord Bute had a passion for the paranormal; in fact, you could call him one of Britain's first ghost hunters. Which makes it quite appropriate that some of the places associated with their time in the city are now considered to be haunted themselves and continue to inspire modern-day investigators in their search for the supernatural.

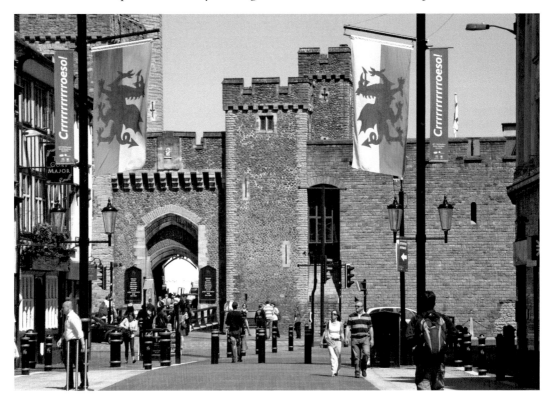

Cardiff Castle. (Jon Candy, CC BY-SA 2.0)

The 3rd Marquess of Bute

The reign of the Butes in Cardiff began with John Crichton-Stuart, 2nd Marquess of Bute. He established Bute Docks in 1839 from which the coal and iron from his many Glamorganshire landholdings could be shipped far and wide, improving both his own and the future city's fortunes in the process. His name lives on in the Butetown area and following his death his estate was inherited by his son, John Crichton-Stuart, 3rd Marquess of Bute. A man of many interests, he was a devout Catholic despite social pressure to be otherwise, and a philanthropist who, while benefiting greatly from the hard work of his sizeable Welsh workforce, did much for the local area. He was also deeply interested in life after death, a popular subject in the Victorian age with spiritualism at its height. In 1882, the Society for Psychical Research (SPR) was founded in London by some of the country's leading academics to investigate psychic phenomena, and Bute was quick to befriend them. He funded investigations into some of Britain's 'most haunted' places, and his first-hand views on such matters were published in *The Most Haunted House in Scotland*, an extensively detailed study of Ballechin House with the 'medium' Ada Goodrich Freer. Bute's relationship with the SPR went beyond simply being a wealthy benefactor and following his death in 1900, founding member Frederic W. H. Myers wrote a glowing obituary. He recalled how his friend would passionately defend the act of speaking with spirits: '"A cruel superstition!" he said once of those who would presume to fetter or forbid our communication with beloved and blessed Souls behind the veil.' Whether Bute communicated with Myers from the other side is unknown, but he continues to cast a shadow over Cardiff today, in the many places he once lived his life, and in a more literal sense in Cathays Park. When Bute agreed to sell the land to Cardiff Council he specified that a triangular area named Friary Gardens should remain

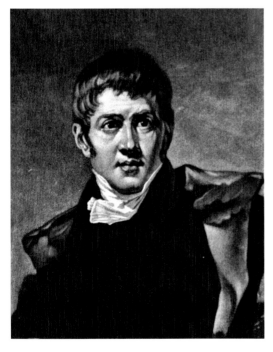

John Crichton-Stuart, 2nd Marquess of Bute.

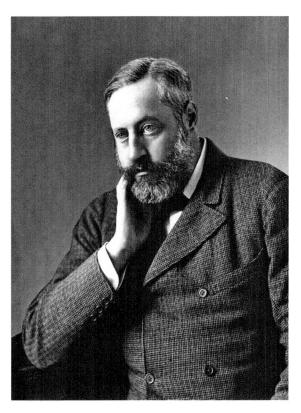

John Crichton-Stuart, 3rd Marquess of Bute.

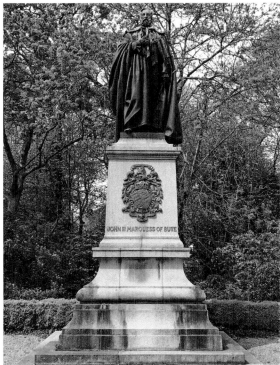

Statue of the 3rd Marquess of Bute in Friary Gardens. (Seth Whales, CC BY-SA 4.0)

The Gorsedd Stones in Bute Park. (Ruth Sharville, CC BY-SA 2.0)

as an ornamental garden, and there a sculpture of Bute by Scottish sculptor James Pittendrigh Macgillivray now stands. With Bute himself keeping a close eye on the place, any building work would surely displease his spirit.

The Lady of the Docks

Central to the Butes' transformation of Cardiff was the docklands area, which was not only in need of a good makeover but was also said to be haunted. A ghostly lady in black would appear after sunset near the old sea-lock, and witnesses assumed that she was searching for something by the way she acted. She would wring her hands and walk back and forth, occasionally approaching people with her arms outstretched and pleading for assistance, and they would understandably recoil as she edged closer. Eventually, a sea captain held his nerve long enough to ask what was wrong, and she explained that she needed passage to the mouth of the River Ely. Anyone who helped her would be handsomely rewarded, and the lure of the money outweighed any concerns he might have had about her paranormal nature. He agreed to row her to her destination, but there proved to be a problem – she was incredibly heavy, the exact opposite of what you might expect from an ethereal creature. What should have been a simple task for an experienced seaman felt like rowing through treacle, and his passenger grew increasingly concerned that the vessel might capsize. She suddenly said to him: 'Land me quickly, and draw up the boat.' He did as instructed, and was

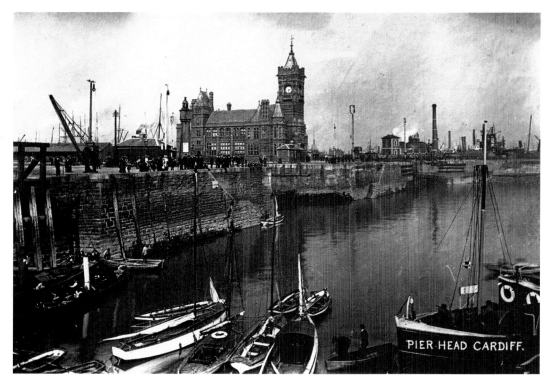

Pierhead, Cardiff, *c.* 1905, by Martin Ridley.

Oxbow feature on the River Ely. (Mick Lobb, CC BY-SA 2.0)

then told to follow her into the woods. Although apprehensive about following the spirit into the darkness, he was motivated by the reward and decided to proceed. Upon arrival at a large stone, he was asked to remove it, revealing a sight that made the whole ordeal worthwhile: a hoard of gold coins. As he gazed at the money the lady in black, having seemingly accomplished whatever had plagued her for so long, vanished into thin air. The skipper gathered as much gold as he could carry and lived the rest of his life a rich man, returning to the stone whenever he needed extra funds.

In more recent times, another ghostly lady was making headlines in modern-day Cardiff Bay when a woman dressed in a 'Victorian' style was captured on Google Maps seemingly floating in front of Wales Millennium Centre. The story was quickly dismissed, however, when the same location was checked from a different angle, revealing that it was a woman dressed in period costume who was very much alive and walking.

Cardiff Castle

Bute's home-from-home in Wales was Cardiff Castle on Castle Street, a sprawling fortress that combines historical ruins with the Victorian veneration for all things medieval. Aspects of the building, such as the Norman keep, hail back to much earlier times, while the mansion itself was conceived by the architect William Burges. A leading figure in the Gothic Revival movement who rubbed shoulders with the Pre-Raphaelite Brotherhood, Burges shared Bute's passion for architecture that reflected a more spiritual age, and their preoccupation with elaborate decoration and

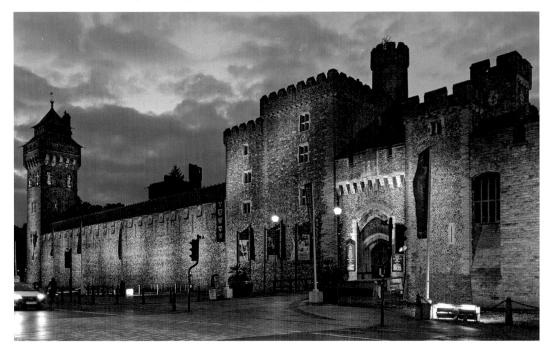

Cardiff Castle. (The Wub, CC BY-SA 4.0)

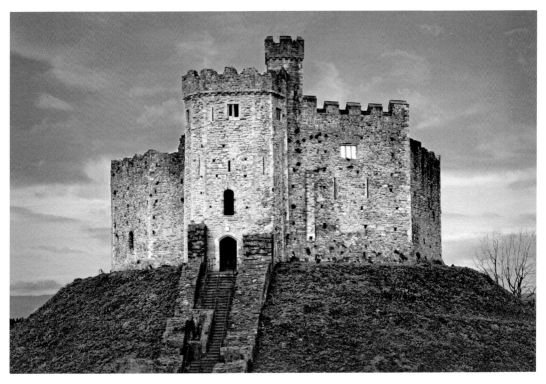

The Norman keep at Cardiff Castle. (Alison Day, CC BY-ND 2.0)

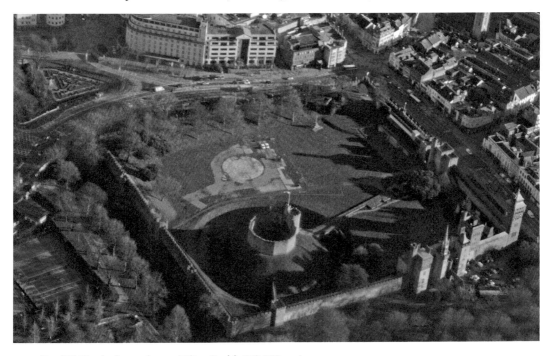

Cardiff Castle from above. (Clint Budd, CC BY 2.0)

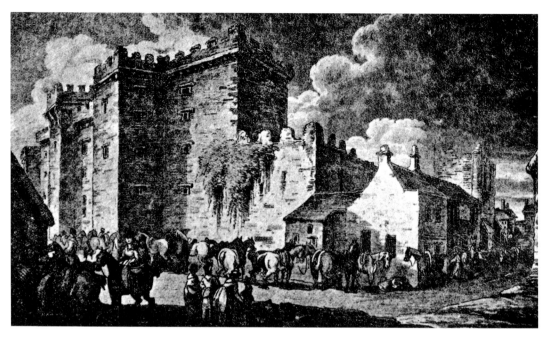

A print of Cardiff Castle dated 1799.

Cardiff Castle's catacombs. (It's No Game, CC BY 2.0)

heraldry is what informs the design. Of course, no romantic castle would be complete without its very own ghosts, and fortunately for Burges, the castle already had several of those and, if the stories are to be believed, a few more have been added since the castle passed into the care of the City of Cardiff. While the ghostly accounts have evolved over the centuries, they suggest that paranormal activity can occur at all hours of day and night, with reports of such traditional phenomena as moving objects, unexplainable sounds, sudden chills, and strange shadows dancing on the walls.

An invaluable source of information are the custodians who, by the very nature of their work, spend more time at the castle than anyone else. There are rooms such as the banqueting hall and library where their dogs have refused to enter, and one claimed to have seen a grey figure at the end of his bed which quickly disappeared. One ghostly visitor first reported by a former custodian is believed to be the 2nd Marquess himself, who died suddenly in his dressing room in 1848. He is now said to walk the castle at night and, while his exact route varies slightly in the retelling, doors and walls are no obstacle as he makes his way from the fireplace in the library to the room in which he died, which was subsequently converted into a chapel. The ghost of a woman in a long robe has also been seen, and it has been suggested that she could be Lady Sophia Rawdon-Hastings, the 2nd Marquess' second wife who seemingly holds a grudge in the afterlife, having been unhappy with his decision to be buried next to his first wife. A far more terrifying-sounding spectral lady is said to haunt the dining hall. Described as a 'faceless vision in flowing greyish-white skirts', the room is best avoided at 3.45 a.m. when the doors open and close by themselves as the lights flash on and off. This 'grey lady' has also been described as resembling a nun, which may or may not be the same nun-like spirit seen on more than one occasion in the ladies' toilets. She answers to the name Sarah and is accused of venturing into the stockroom where she rearranges objects. In one creepy encounter a custodian noticed her in the reflection of a mirror and then felt a tap on her shoulder. When she turned there was no one there, but when she turned back the spirit had moved even closer in the mirror. She shouted at Sarah to get back, and the spirit did as instructed.

Phantoms of the Streets

The ghosts of Cardiff Castle are not confined to the building itself and might be encountered in the streets outside. A grey lady wearing a hooded cape has long been sighted travelling from Station Terrace, where her starting point is believed to be opposite Queen Street station, towards the historical area of Crockherbtown, now the eastern end of Queen Street. She continues onto Duke Street, directly past the Rummer Tavern, itself home to a ghost story or two, and after passing the front of the castle walks onto the bridge crossing the river. Here she stops and turns to look back before vanishing, and some believe she is waving or signalling to an unseen acquaintance inside the tower. One theory suggests that she has a connection with Robert Curthose, William the Conqueror's eldest son, who was imprisoned there until his death in 1134 following a failed attempt to overthrow his younger brother, Henry I of England. Wirt Sikes writes that there are conflicting legends concerning Robert's potential time at the castle, with the more bloodthirsty accounts claiming he was confined to a dungeon beneath the tower, his eyes 'plucked out' on arrival and dying of a 'great melancholy'.

A bear on the Animal Wall in Bute Park. (Pete Birkinshaw, CC BY 2.0)

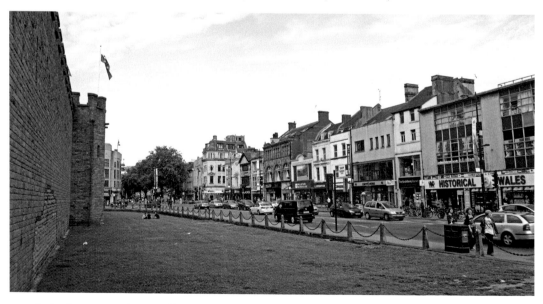

Duke Street, outside Cardiff Castle. (Allie_Caulfield, CC BY 2.0)

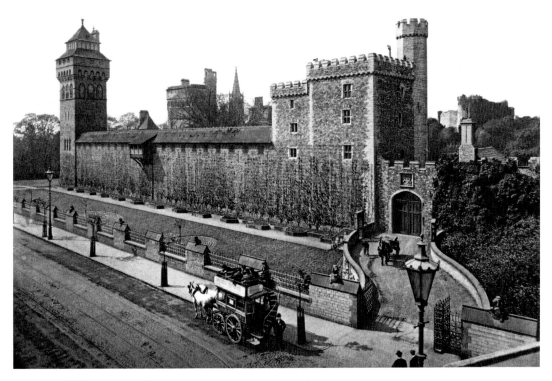

Cardiff Castle from the south-east between 1890 and 1900.

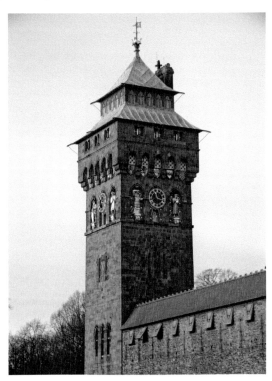

Cardiff Castle clock tower. (Jon Candy, CC BY-SA 2.0)

On the other hand, it was also said that he had a relatively comfortable time at the castle and was given free rein to roam with clowns to amuse him – this version of events, however, doesn't lend itself so well to ghost stories.

Another spectral visitor who hurtles towards the castle but from the opposite direction is a phantom horse and carriage that clatters to a halt as it enters the courtyard. Some have claimed this is an ominous omen of a death in the family, and that it might not be confined to Cardiff, having also been seen at Dumfries House in Ayrshire, Scotland, which remained in the Bute family until 2007.

Castell Coch

Castell Coch is Cardiff's fairy-tale castle, a romantic folly that peers over the trees above Tongwynlais. Its name translates as Red Castle and is so called after the colour of its original sandstones. Now cared for by Cadw, the castle as we see it today is again the handiwork of Bute, who commissioned Burges to work his magic on what was intended to be a countryside retreat. Burges was clearly proud of his design and made a replica of the tower at his home in Kensington, but it would also prove to be his last for Bute, and he died with only the exterior completed. The interior was finished in the spirit of Burges' vision, and as with Cardiff Castle, is dotted with Gothic adornments, from the statues of the Three Fates in the drawing room, to the allegory of Sleeping Beauty above Lady Bute's bed. Bute spent very little time at the completed castle, possibly due to the passing of his good friend, but it became an instantly recognisable landmark for the locals, towering over the surrounding forest.

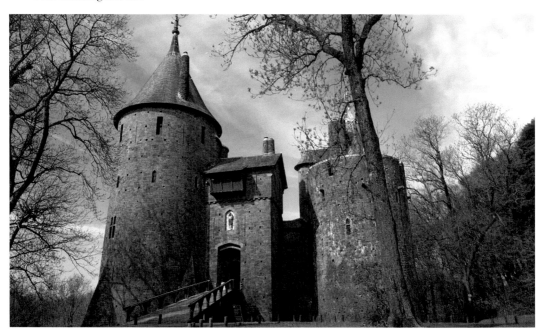

Castell Coch. (Hannah Cook, CC BY 2.0)

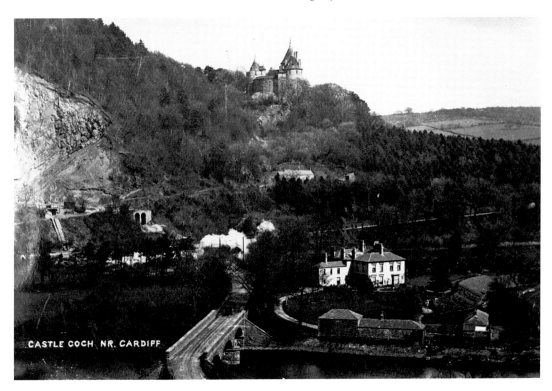

Castell Coch *c.* 1905, by Martin Ridley.

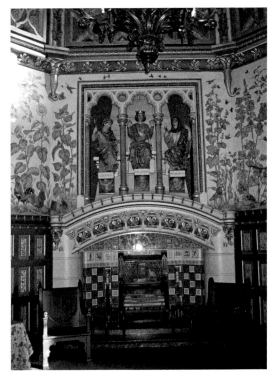

The drawing room at Castell Coch. (artethgray, CC BY 2.0)

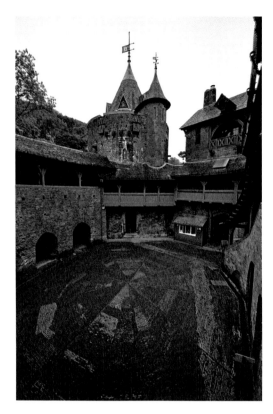

The courtyard at Castell Coch. (Nilfanion, CC BY-SA 4.0)

Castell Coch was built on the foundations of a thirteenth-century castle which was itself established on an even earlier fortification which, according to legend, was built for Ifor Bach, the Lord of Senghenydd. A ruler deeply concerned about dying, or more specifically the fate of his lifeless body and his riches, he arranged for both to be buried deep below the castle. Two stone eagles were stationed to keep guard, but these were no ordinary stone eagles – they were two trusty guards magically transformed to watch over him. When two thieves inevitably entered his tomb, these inanimate guardians sprang to life and ensured nobody else would be foolish enough to attempt anything similar. This legend appears in various forms, some of which omit Ifor Bach, others which claim the robbers returned several times and were increasingly beaten each time, but the moral of the story remains the same: don't try to steal the treasure or the eagles will get you.

Another tale which may or may not be related tells of a ghostly cavalier who haunted the ruins before Burges' makeover. A woman was staying at the castle with her servants and friends, and when they were disturbed by strange noises, they assumed it must be rats. When the woman awoke one night to find she was not alone, however, they assumed otherwise. Standing in her room was the apparition of a man dressed as if from the early 1600s, who stared directly at her with a sombre expression. She rose from her bed, but as she did so, the man disappeared through the door, and when she gave chase, she discovered the door was locked tight. The activity increased afterwards and she saw the night-time visitor on several occasions, and while the woman was determined to solve the mystery, her fearful companions eventually convinced her to

leave. One local legend which might shed some light on the events claims that during the English Civil War, a hoard of treasure was buried deep beneath the castle, and that this ghostly cavalier was searching for it. This legend shares similarities with that of Ifor Bach, and it was suggested that the treasure was buried in a subterranean passage that once connected Castell Coch with Cardiff Castle. This idea might stem from the fact that 'curious holes' in the grounds of Cardiff Castle were once thought to have led to the other side of the River Taff. Could it be possible that they went further still?

The grounds of Castell Coch are also said to be haunted by a mysterious lady named 'Dame Griffiths'. She is possibly dressed in grey and walks the land in search of her son's soul who died in a drowning tragedy. Another ghostly woman said to roam the area is Mallt-y-Nos, the name given to a folkloric 'night-fiend' who shrieks at those doomed to die. In Welsh mythology she is known as Matilda, a lady who loved hunting so much that following her death, she became a companion of Arawn, king of Annwn (the Otherworld), and forms part of his wild hunt during which she urges the Cŵn Annwn (hounds of Annwn) onwards.

Paranormal Pioneer

While Bute was quite open about his spiritual beliefs, for many people in the public eye, it was often considered best to keep them secret to avoid potential ridicule. One councillor for Cathays, however, with very similar opinions to both Bute and the newly formed SPR, was more than happy to discuss his ghost-hunting antics. In fact,

A view of Cathays with National Museum Wales in the foreground. (Jeremy Segrott, CC BY 2.0)

when it became public knowledge that he was something of an enthusiast, he even invited a reporter to his office to explain his theories. What is remarkable is that, while more than a century has passed since Henry White gave that interview, many of his ideas still apply today, and might even teach modern-day ghost hunters a thing or two.

White was also a landlord, and it all began when a would-be tenant asked if she could rent his cottage on Merthyr Street for herself and her parents. He did the usual checks, and all seemed in order except for one red flag: they already rented a property nearby and had been there for less than a fortnight. Why did they want to move so soon? The young woman had no choice but to tell the truth, that as far as they were concerned, the house was haunted. White, having an interest in such matters, was sympathetic to her plight, and made a somewhat unorthodox offer; he would let them rent his property if he could first visit their current home and investigate for himself. He discovered that loud knocks were heard on the walls at the stroke of midnight, and that the neighbours had been ruled out as the source. Previous tenants had also left quickly because of the noises, with those before them lasting a month, and those before that only a week. There was also a story of a former occupant who had died from poisoning that might offer a clue as to the spirit's identity. White believed the fact that the ghost was only heard and never seen added to the believability of the accounts, for any human banging on the walls would surely have been detected, and he considered it a case worthy of study by the SPR themselves.

Following these events, White spoke with the press, and he explained that while he hadn't seen a ghost himself, that didn't mean they didn't exist. In much the same way as having never seen a rhinoceros, people didn't doubt their existence. He proposed that anyone wishing to investigate paranormal phenomena should begin by studying the subject thoroughly by reading several recommended books and making notes. Next, the ghost-hunting group should get together and discuss their findings, comparing notes and sharing views. Then, and only after much preparation, are they ready to begin a course of investigation, which is planned beforehand and, crucially, followed through to a conclusion. In this respect, a ghost hunt should not be something you do for one night, but an ongoing project that is repeated until resolved. Finally, he says that all investigations should be 'thoroughly honest, conscientious, and honourable' – a motto that still rings true today.

Modern-day Investigators

When it comes to investigating strange phenomena in Wales's capital city, they don't come much more illustrious, or prolific, than the husband-and-wife team of Lionel and Patricia Fanthorpe. The pair have published widely on such diverse topics as the Knights Templar and the mysteries of numerology, and Lionel is fondly remembered by many as the motorcycle-riding priest who presented Channel 4's *Fortean TV*. Having settled in Cardiff decades ago, Lionel says that: 'Cardiff might well lay claim to being the haunted capital of Wales. Having lived here happily over the past forty years we have become very fond of the city and our many friends and neighbours who share it with us.' When it comes to choosing a favourite supposedly haunted place to visit, he says they love Castell Coch as well as nearby Caerphilly Castle: 'Both

Lionel Fanthorpe.

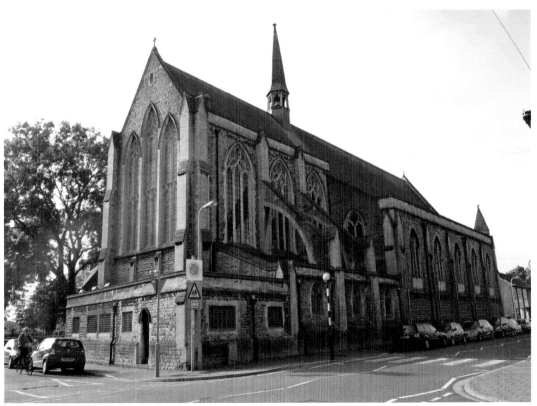

St German, Roath. (The National Churches Trust, CC BY 2.0)

A paranormal investigation. (Lucky Louie, CC BY-SA 3.0)

have very mysterious atmospheres as though powerful forces from the past were still present in the stones.'

Lionel's most memorable case in the city occurred while he was carrying out his clerical duties in Roath. He recalls that: 'When I was serving as an assistant priest at St German's in Cardiff, two old ladies who lived in the parish came to ask for help as they felt that their house was haunted. They had never seen anything paranormal but when they came home after being out shopping, or on a family visit, and entered the ground-floor part of their house they distinctly heard footsteps coming from the room above. Not lacking in courage, they went upstairs to confront the supposed intruder – but there was no one there. When they were upstairs, they heard footsteps downstairs! I went to the house with them, said prayers of exorcism and sprinkled holy water upstairs and downstairs. A few days later they came to see me and reported with delight that since the exorcism they had had no further psychic problems.'

Lionel is also the president of ASSAP (Association for the Scientific Study of Anomalous Phenomena), a charitable society dedicated to furthering investigation and education in paranormal matters. ASSAP emphasise the importance of investigating in a scientific and ethical manner and offer training weekends for would-be investigators to become AAIs (Approved ASSAP Investigators). Having qualified, members are then listed on the National Register of Approved Investigators and can look at joining one of the many affiliated groups around the country. One such group with two qualified AAIs actively investigating anomalous phenomena in and around Cardiff is

Leanne Roberts and Sarah Liney from Cymru Paranormal.

A photograph taken by Leanne Roberts during an investigation in Llandaff.

Cymru Paranormal. Established in 2016, they describe themselves as a 'professional non-profit-making group' who 'operate under a strict code of conduct and ethics'. Using scientific methodology, their investigative techniques combine traditional tried-and-tested methods of data gathering such as good old pen and paper and thermometers with high-quality voice recorders and cameras, both still and video. Of all their investigations, lead investigator Leanne Roberts says that Llandaff has been her favourite place in Cardiff where she has 'encountered many unexplained experiences including shadow figures, lights and a feeling of unease'. Founder Sarah Liney singles out Llancaiach Fawr Manor in nearby Treharris as her number one location anywhere in Wales where she has had 'many personal experiences which remain unexplained to this day'.

Dark Folklore

The earliest accounts of paranormal activity in Cardiff are steeped in the dark folkloric traditions of Wales. The most numerous are the death omens, eerie sights and sounds that warn of an upcoming demise in the locality. Corpse candles (*canwyll corff*), hovering lights that foreshadow such an eventuality, have long been sighted bobbing along the River Taff and floating in St Fagans. Their appearance and location offer some clues as to how the unfortunate individual might die, such as lingering over a body of water ahead of a drowning or travelling along the same path a funeral will soon follow. Other death omens can be more cryptic but no less deadly. For example, a hawthorn tree at a lonely house that once stood in Canton would burst into bloom

As the shades of night fall... (Jo Naylor, CC BY 2.0)

for only three nights of the year before withering. If it blossomed for longer, a death could be expected. As we shall see, death omens come in all shapes and sizes, in all parts of Cardiff.

The Curious Coffin Maker

Just before the witching hour one dark Sunday night, a farmer living in an unidentified village a few miles west of the city noticed a dim light burning in the house next door. It was coming from the workshop of his neighbour, a carpenter who would not usually be working at midnight, and he assumed it was thieves. He quickly dressed and crept into the lane where he could distinctly hear a familiar sound that suggested it might not be burglars after all – somebody was making a coffin. It was possible, he said to himself, that the carpenter had received a last-minute order and was putting in some overtime, but he wanted to be certain before retiring to bed, so he peered through the open doorway and saw the person making a coffin. It was not his neighbour, but it was someone he recognised, a rough and rugged poacher with a notorious reputation. Wisely opting not to tackle the man alone he informed the local policeman, but when the pair arrived on the scene there was no sign of the poacher, or even a break-in. The door was locked, and the light extinguished. The carpenter was informed early next morning, but following a careful examination they could find no evidence of the room being used overnight. Nevertheless, the farmer was convinced of what he had seen, and the story was spread far and wide. It even reached the ears of the poacher accused of breaking in, who insisted he was in Cardiff that night. And yet there was

A creepy coffin. (Fredrik Andreasson, CC BY 2.0)

to be a twist in the tale. A few weeks later, the poacher, seemingly up to his old tricks in a field near the farm, was fatally shot in an accident. As they awaited the inquest, his body was transferred to the carpenter's workshop.

Cry of the Cyhyraeth

The cyhyraeth is a death omen that is heard rather than seen and, if folklore is to be believed, at least one is active in the grounds of a church in Cardiff. A particularly loud groaning spirit that makes a terrifying noise, its wailing has long been heard along the Glamorganshire coast, drifting towards the shore from far out at sea. Much like the waves, the moaning sounds increase and decrease in volume with the ebb of the tide, creeping up on their victims before surprising them with a deafening cry. Occasionally, these eerie sounds are accompanied by corpse candles hovering on the water. The combination of these two death omens is considered exceptionally unlucky, as the sinister lights foreshadow a wreck and the accompanying scream warns that dead bodies will soon be washed up to shore. The cyhyraeth is equally deadly inland, where it rattles windows and opens doors as it moans through the empty streets at night. If the cyhyraeth visited a property then bad news could be expected for at least one inmate, or it could even be a warning of an epidemic. In one account, a boy heard sobbing coming from the churchyard of St Mellons Parish Church while running an errand. He went in search of the source of this crying, but it seemed to be moving around the churchyard from one location to the next before finally settling in a third and final spot. Sometime after, a coffin was brought to the churchyard to be buried,

Waves crashing on the Glamorganshire coast. (Simon Rowe, CC BY 2.0)

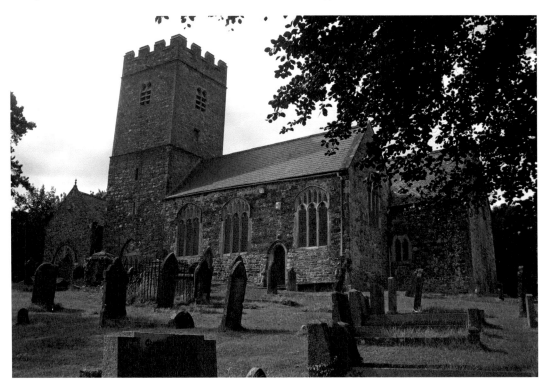

St Mellon's parish church. (John Lord, CC BY-SA 2.0)

Churchyard at St Mellon's. (John Lord, CC BY-SA 2.0)

but they discovered that the designated plot had already been claimed. Having no choice but to move the coffin to another plot, they then discovered that their second choice was already occupied. They finally took the corpse to a third location and gave it a proper burial, the same place where the boy had heard the crying coming to a halt. A spirit has also been sighted nearby by another witness who claims it was 'sitting upon the old stone cross which stands on the hillside near the church'.

The Vampire Bed

Wales is home to more than its fair share of strange folkloric horrors, but Cardiff is home to possibly the strangest of all – the vampire bed. Yes, the vampire bed, a piece of furniture that, much like Count Dracula, drinks human blood at night. It was in the early seventeenth century, when the witch-crazed James I of England was on the throne, that a young family in Cardiff picked up what appeared to be a bargain at a bankruptcy sale. The heavy old four-posted bedstead was placed in the best bedroom by its new owner, a room that was rarely slept in and saved for impressing guests. All was well for some months, but one night while the man was away part of the floor in the bedroom he shared with his wife became damaged. She decided to relocate into the best bedroom with their four-month-old baby, but on the first night the child was restless. The second night was worse, with the little one screaming out violently and unable to be pacified. The doctor was called for and prescribed something to help the infant sleep, and while the third night was better, the baby was still agitated. It was a short-lived respite, and on the fourth night the child was crying louder than ever. The mother gathered the child in her arms and the weeping soon stopped, but tragically, it stopped forever – the child was dead. On its neck was 'a large mark with a red spot in the centre, through which blood was oozing'. The doctor was summoned once more

The bite of the vampire.

but he could no more explain the 'extraordinary mark' than he could revive the child, making the rather unpleasant comparison that: 'It is just as though something had caught at the child's throat and sucked the blood, as one would suck an egg.'

With no explanation forthcoming, it was eventually considered to be one of life's unexplainable tragedies and things returned to normality. The couple were blessed with a second child, and as a result the best bedroom was used once more, but not by the mother and child, but the father who needed to catch up on his sleep. On the very first night, he was rudely woken when he felt something clutching at his throat, but dismissed it as a nightmare. When the experience repeated itself on the second night it was more difficult to ignore, and on the third night he was almost suffocated. Springing from the bed, he looked in the mirror and saw on his throat 'a large space of skin as if it had been sucked, and from the centre blood was oozing'. The description was very similar to the wound suffered by the child, and to check if it was his imagination he asked a friend to spend a night in the room, who reported experiencing the same. As a result, the man decided to consult an expert of such things, who informed him that he was in possession of a vampire bed. Curiously, he did not then destroy the bed, nor did he use it again either, but decided to keep this 'uncanny piece of furniture' as a curiosity. Which begs the question, is the vampire bed still in Cardiff today?

Secrets of the Ash Tree

In around the year 1756, a man called Evan Gibbon, a servant of John Thomas of Tŷ'r Ffynon in the parish of Llanedeyrn, stopped at the house of an acquaintance as he walked home where he received an ominous warning: he would meet a terrifying spirit that night. While some might have laughed off such a prediction, Gibbon had long felt some 'terror in the night' and took the threat seriously. As such, two fellow servants escorted him for part of his journey and, sure enough, when they reached the location, he saw the spirit of a woman in a distant field. She was perched on a stile that blocked his way which left him no option but to engage her in conversation. He demanded to know why, in the name of God, she troubled him, and they argued until the spirit vanished from sight. Yet he could still hear her, and when he asked where she was she replied: 'sometimes in the clouds and sometimes in the earth, seventy years'. The implication was that despite being dead and buried long ago, she was trapped in our world and would only leave him alone if he completed a task for her. She asked him to remove a weeding instrument, presumably a hoe or a similar tool, from the nearby ash tree. It sounded like a simple enough task, but on inspection Gibbon discovered that the tree had grown its gnarly branches around the instrument, and he would need to return with a hatchet to cut it free. True to his word, he returned and hacked away, only to discover that the instrument was so old and rusted that it disintegrated the moment it was freed. With the task complete the spirit asked him to lie down face first. He did as instructed and, from his lowly position, noticed a great light appear inside of which was 'a young woman with a clean face; without a cap on her head; with her hair plaited or tied up (he could tell not which); and had a petticoat, such as he heard worn by women in former times'. The light faded from view, and with it the spirit. She was free.

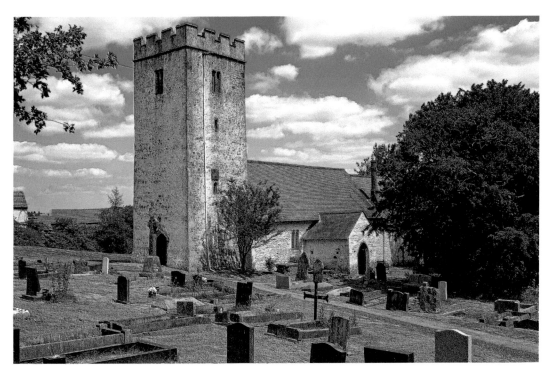

St Edeyrn's Church, which is thought to lend its name to Llanedeyrn. (Richard Williams, CC BY-ND 2.0)

As ash tree at the National Botanic Garden of Wales (Clint Budd, CC BY 2.0)

Haunted Holy Wells

There were two holy wells in Cardiff that were both said to be haunted by phantom ladies. They were located to the north and the south of Roath Park, which incidentally, also has a phantom lady of its own. She appears beneath a tree at midnight and waves at the lake where, according to legend, her lover drowned in a swimming accident.

In the nineteenth century, it was recorded that a miraculous well in Llanishen could cure complaints, but there was one drawback – it was also haunted. The spring is believed to have attracted Saint Isan to the area in the sixth century, the patron saint of Llanishen who founded a church on the same site, which now forms part of the Oval on Llandennis Road. Referred to as St Dene's Well but also known as Ffynnon Llandennis, the magical water was claimed to help with all manner of ailments, especially those related to scurvy. It was also associated with a grey lady who is said to have been fascinated by drovers who would have regularly guided their livestock along this route. She would trail behind them for a mile or so before returning to her watery abode, where some believed she was trapped for committing 'evil deeds'. Unlike similar tales where the imprisoned soul is eventually set free, this one comes with an ominous postscript: 'there was no story about her release'.

The second well is Penylan Well located near the southern end of the park. Also believed to have magical properties, it was said that if you drank the pure spring water before dropping a pin into it your wishes would be granted for the next year. It was particularly powerful on Easter Monday when people flocked there for all manner of reasons, from forecasting the future to working charms. It was also haunted by a ghostly woman who appeared in 'sombre garments' and would wail and moan at

The Scott Monument near the dam at the south end of Roath Park Lake. (Richard Szwejkowski, CC BY-SA 2.0)

Sunset in Cardiff's parks. (Richard Szwejkowski, CC BY-SA 2.0)

The park in Penylan. (gordonplant, CC BY 2.0)

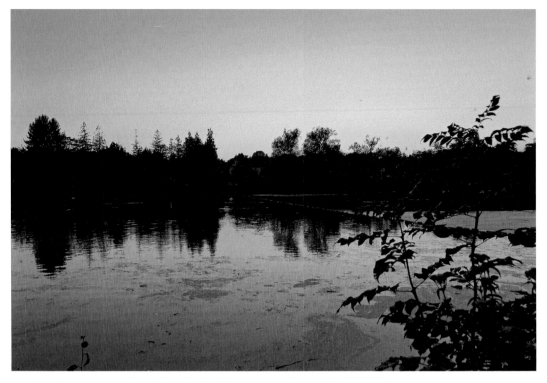

Evening comes to Roath Park Lake. (Richard Szwejkowski, CC BY-SA 2.0)

twilight. One brave local eventually approached the spirit, and she explained that she needed human contact to be free. More specifically, she asked him to hold her firmly by the waist and to remain silent, a strange but simple request he was happy to oblige with. As he did so a sharp pain shot into his arm and the cramp caused him to loosen his grip. It would prove to be a costly slip because the enraged woman fled the scene in floods of tears, lamenting that it would be 'two hundred years more before I shall be free!' As with the spirit of the Oval, there is no record of her being released.

The Devil Went Down to Ely

The Devil has long plagued the God-fearing people of Wales, and in several old folk tales Satan and his minions were often blamed for activity that might nowadays be attributed to malicious spirits. In the more fantastical accounts, Old Nick was often outwitted by the wise old Welsh women and the quick-thinking farmers who made him look like a fool, yet laugh as they might, the personification of evil was a very real and ever-present threat. Wirt Sikes noted how Cardiff was a deeply Christian society, and that its 'moral tone' was reflected in its many churches and chapels. One man who grew up in the early 1800s recalled how the local congregation would spit violently in church whenever the Prince of Darkness' name was mentioned. As children they would avoid the dragonfly simply because it was known as the Devil's messenger, and the Devil's fish which wallowed up the full-moon tide in the River Taff. Areas

Mile marker on A48 outside Ely cemetery. (Tony Hodge, CC BY-SA 2.0)

known to be frequented by the Devil were given a wide berth, and when his parents took him near such locations on horseback he would bury his head in his hands. One place which struck fear into his heart was a nook near the Dusty Forge in Ely, an old inn on Cowbridge Road which once served as a mail-coach stop on the road to Cardiff. He would let out a heavy sigh of relief as they travelled past the inn which, so the legend goes, was named after a visit from the Devil, as was another similarly named Glamorganshire drinking establishment. It was said that an old forge once stood nearby and at midnight while the blacksmith was away his wife heard it roaring into life. Sneaking out to investigate, she saw a bulky blacksmith with horns on his head and a long tail hammering a shoe for his cloven hooves. Thinking quickly, she disturbed the sleeping hen house and, as the cocks crowed as if morning had broken, the furious Devil fled the scene so quickly he left behind his unfinished shoe.

The Silent Man of Ely River

A creeping spirit dubbed the 'silent man' was said to haunt the road from Canton to Leckwith. A man who had a first-hand encounter with the apparition recalled feeling a shadow following him that didn't utter a word. The man grew impatient, and possibly scared, and tried both swearing at and begging his pursuer to leave him alone. He received no reply; the spectre simply gazed longingly at him and dogged his footsteps. Finally losing his temper, he shouted: 'In the name of God, what do you want?' With

The old Leckwith road bridge crossing the River Ely. (Mick Lobb, CC BY-SA 2.0)

Rail bridge over the River Ely. (Andrew Rees, CC BY-ND 2.0)

that, the spirit broke his silence, but not with words – he began to sob. He explained that he had been unable to speak with anyone until he was asked to do so in the lord's name and was doomed to wander the earth until his head, or more specifically his skull, was buried. He said that: 'I was boatman down the Ely river, and my head is on the bank and devils do play football with it. If you will come and bury it I shall rest.' It sounded like a strange request – devil's playing football with a skull? – but the man agreed and was directed towards a bend in the river just above the Taff Railway Bridge. There, in a bluish light, he saw what appeared to be a group of people playing football which, on closer inspection, were indeed 'devils' having a kick-about with this poor soul's skull. With God's might on his side, he strode towards them saying prayers and, as he did so, the demons fled, leaving their plaything behind. The skull now retrieved, he took out his knife and dug a grave, and as it was buried the ghost 'went out like smoke'.

Spectral Ladies of Pentyrch

The mysterious grounds of Castell-y-Mynach (Monk's Castle) are said to be home to a ghostly white lady. The Grade II* listed medieval mansion house on the south side of Creigiau was originally built for the Matthew family who owned ironworks in nearby Gwaelod y Garth during the sixteenth century. Their home was given a major facelift in the seventeenth century, which included extending the property, and it is

Castell-y-Mynach farmhouse. (Dr Mary Gillham Archive Project, CC BY 2.0)

The Garth. (Owen Mathias, CC BY-ND 2.0)

Fields near Gwaelod-y-Garth. (Gareth James, CC BY-SA 2.0)

now surrounded by a housing development. One witness who saw the spirit walking among his plants was the gardener, who described her as wearing a dress 'as white as the driven snow' with long black hair that 'streamed over her shoulders'. She clutched a bunch of forget-me-nots in one hand and used her right hand, which was covered in sparkling rings, to summon him nearer. The terrified man did the opposite, and instead of approaching ran for the safety of the house where he breathlessly informed his employers that he'd seen the white lady. They followed him back outdoors, and when the gardener shouted 'there she is' she disappeared. It has been suggested that the ghost appears to guard the treasure of the monks who lend the mansion its name.

Another popular colour for such spectral ladies to wear is green, and the residents of Pentyrch might catch a glimpse of a lady in green by looking up at Garth Hill (*Mynydd y Garth*). According to local lore, she was often spotted roughly halfway up the Garth and would try to catch the attention of men as they walked by. The majority ignored her and picked up their pace instead, but eventually two brave souls engaged her in conversation and she explained that she was trapped guarding a hoard of treasure. She could only be released when the vast fortune was removed and offered them a seemingly simple choice: if she revealed the location of the treasure, they would become rich instantly and set her free at the same time. If, however, they ignored her plight, now that they'd stopped to talk to her, no other man would be able to help her for two centuries. The men considered it to be too good to be true and possibly even a trap, but after noticing the gold dust on her slippers decided to trust her and offered their assistance. As they did so, she vanished before their eyes. They had taken too long debating whether to help, and she was now seemingly trapped for another 200 years. For a long time afterwards, her 'sobs and wailings were heard', and while no date is given for this tale, it is likely that the 200 years have since passed, and she might once more be stalking the Garth in search of assistance.

Communicating with the Dead

In the nineteenth century, spiritualism was all the rage. Having been popularised in America by two young girls called the Fox sisters, who claimed they could communicate with the dead using a system of asking questions and receiving 'raps' in reply, it spread like wildfire across the Atlantic. There were spirit mediums plying their trade in every major town and city in Britain, and Cardiff was no exception. Anyone could join in with a séance, and for many this act of joining hands around a table and receiving messages from dearly departed friends and family was clear evidence of life after death. Others, however, were less than impressed, as one writer to the *Cardiff Times* rather bluntly put it: 'It is just the old story of the stupidly credulous and the trickster who is ready to indulge them in their belief in ghosts and spirits.' Either way,

A lonely tree in Pontcanna Fields. (Jeremy Segrott, CC BY 2.0)

whether you were a true believer or a hard-nosed sceptic, Cardiff was at the heart of the spiritualist movement, producing some headline-making psychics and welcoming high-profile visitors for 'famous' séances.

Is Anybody There?

For a first-hand account of a séance in Cardiff we can turn to Mr Scott from Merthyr Tydfil who attended his first gathering in Roath in 1877. The party consisted of a group of mainly strangers who were led by the medium, and Scott assures us that he checked the room and the medium's cabinet thoroughly beforehand. With the gaslight turned low the session began with the saying of prayers and the summoning of a spirit called Twilight. As the sound of a harmonium played in the darkness the medium entered his cabinet and soon after the first 'materialised spirit' was walking among them. At least nine 'spirits' would emerge in total, ranging in sex, shape and size, from a towering figure more than 6 feet tall to a small baby. One spirit claimed to be the first wife of Robert Dale Owen of America, who is assumed to be the Welsh Victorian social reformer who immigrated to the United States. Scott was an admirer of his works and asked the spirit to write something for him as a souvenir, who more than obliged by scribbling away three full pages. It was the final spirit, however, that

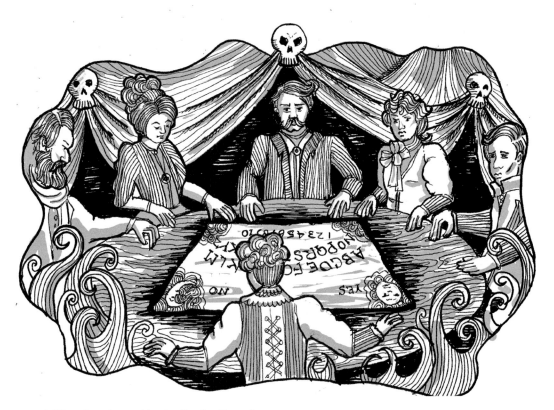

A Victorian séance. (Art by Sandra Evans)

the narrator found most incredible. He saw a child emerge from the cabinet and was told that this was the first time for her to materialise and that her name was Florey Scott. He watched in amazement as she uttered the words: 'I am here, papa; I can materialise.' Scott insisted that nobody in that room could have known how important that name was to him. Florey was the name of his daughter who had died some eight years earlier.

Mysterious Materialisations

The Welsh medium George Spriggs was a prominent 'materialisation medium' of the late Victorian era. He joined a Cardiff spiritual church soon after discovering his powers and would find fame for the way in which the spirits he manifested left his body and walked around independently. He could summon more than one spirit simultaneously, and they could even carry out tasks such as gathering food and picking flowers. Spriggs was also a long-distance medium for, if the reports are to be believed, he had the ability to communicate from one hemisphere to another. After emigrating to Australia, it was in Melbourne in 1884 that Spriggs fell into a trance

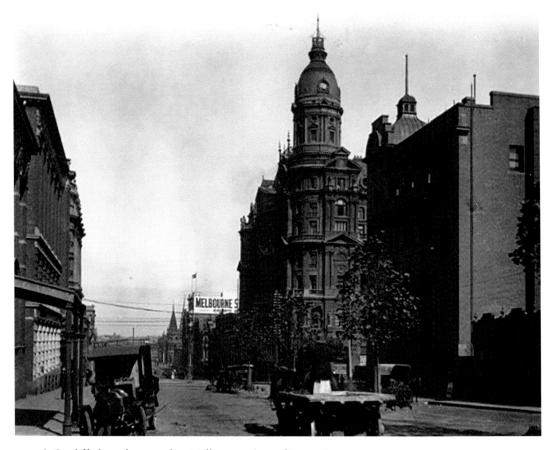

A Cardiff ghost down under: Melbourne, Australia, *c.* 1890.

and began to channel the recently deceased mother of a man who was next to him at the time. They could hear rapping in the room, and Spriggs told his acquaintance that he should check the desk from which the sound was coming in ten minutes. On doing so, he found a handwritten note he 'instantly recognised' as his mother's handwriting, in which she assured him she was happy. Following the experience, Spriggs comforted the man by explaining that it was not unusual for this to happen soon after a death. He recalled how, while in Australia, a spirit named Mrs J of Penylan had 'manifested' to him in similar circumstances, not only from the other side of the veil, but from the other side of the world. She was described as 'an old lady, very poor,' who had passed away two weeks prior and had been clothed and cared for by 'a number of charitable persons in Cardiff.' Nobody in the room had any idea who this woman might be, or had any recent communication with anyone from Cardiff, and afterwards Spriggs wrote to some old friends in Wales to make enquiries. They included Rees Lewis, a prominent member of the Cardiff spiritualist scene, who confirmed that yes, a woman by that name had passed away and at that time. With evidence to back up his messages, Spriggs asked: 'How can we explain this experience in any other way than by recognising the fact that the old lady actually came and told us?'

Back on British soil in the early 1900s, Spriggs recalled in a lecture to the London Spiritualist Alliance two 'miraculous' daylight séances in Cardiff. In the first, a soldier manifested and then vanished through a door. This 'spirit friend', who was some 6 inches taller than Spriggs and covered in a long white robe, walked downstairs and returned with a bowl of fruit which he offered to those in attendance. He also ate some himself – this was a fruit-eating spirit. The second daylight séance was held at the home of Rees Lewis with men of the cloth in attendance. As they sat with their hands on a table they heard a 'rap' and, looking under the table, found 'small bunches of grapes, a branch from an apple tree, and from a pear tree, bunches of wheat and barley, also peas'. One of the holy men is quoted as saying: 'This is as near a miracle as possible.'

The Spectral Dog

Members of Cardiff Spiritual Society regularly communicated with like-minded groups in the specialist publications that were popular in nineteenth-century Britain. These titles allowed enthusiasts to publish reports of their séances and discuss such run-of-the-mill matters as the dates for get-togethers, but they occasionally included articles that were a little more out of the ordinary, like the mystery of a 'spectral dog' in 1877. A local spiritualist recalled how this four-legged spectre had long been sighted 'lying in the middle of one of the old turnpike roads, just outside the town,' and an older inhabitant had personally witnessed the phenomenon more than once in his younger years. He was convinced that the dog was paranormal if for no other reason than its size – at the time Cardiff was still a 'small town', and no dogs of this size were to be found anywhere in the area. A member of his spiritualist circle suggested that maybe the dog manifested itself on the spot where somebody had died of fright 'worried to death by a dog'. He reasoned that by having passed over in such a 'violent way' with nothing but the impression of this beast 'fixed upon the mind', his 'spiritual body' had assumed 'a form resembling that of the animal causing death'. To put that

into plainer English, he suggested that it wasn't the spirit of a dog, but the spirit of a man who died after being frightened by a dog, and with the image so heavily imprinted on his mind he now returned in the dog's form. How likely this might be is debatable, but the good news for the man is that they didn't believe it was permanent. He would eventually return to human form, the length of time determined by the 'intelligence of the individual' – the smarter he was, the less time he'd be a dog. Upon further investigation, the remains of a forest were discovered on a tract of land next to the road where the dog was sighted, which at one time was 'the resort of numbers of wolves'. So maybe it wasn't a spectral dog after all but a spectral wolf.

The Famous Cardiff Séance

On 15 February 1919, one of Britain's most high-profile séances took place in Cardiff. It became known as the 'famous Cardiff séance' for two reasons: firstly, the nature of the activity reported; and secondly, the celebrity status of those in attendance. A party of some twenty people gathered at the home of Mr Wall in Penylan, which included Sir Arthur Conan Doyle, the creator of Sherlock Holmes, and his wife, Lady Conan Doyle, herself a medium. The renowned author of detective stories was a prominent supporter of spiritualism, his passion for which had been fuelled a year earlier when the Welsh medium Evan Powell claimed to have contacted his son Kingsley who had been killed during the First World War. Leading this séance were two local brothers known collectively as the Thomas brothers: the medium Will Thomas, born in 1888 and working as a collier in Gorseinon, and Tom Thomas, who was born in Merthyr in 1881 and acted as master of ceremonies. The scene was set in a first-floor room

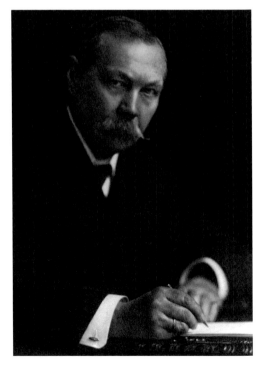

Sir Arthur Conan Doyle.

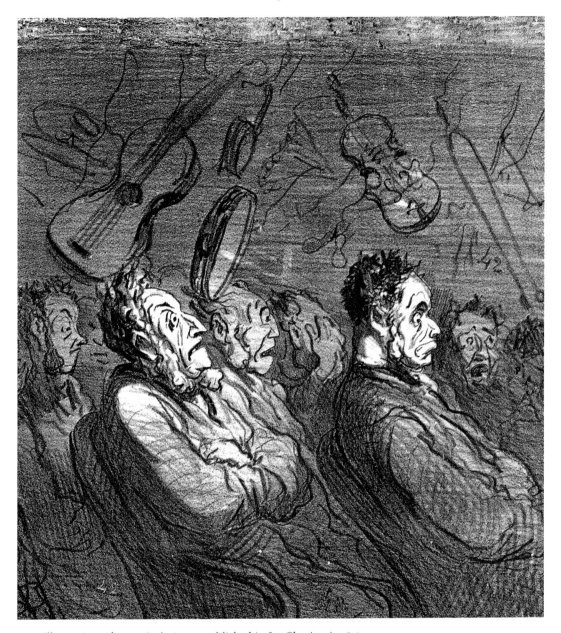

Illustration of a musical séance published in Le Charivari, 1865.

which was sparsely decorated save for a few chairs and the items needed for the main event. These included a what-not, an item of furniture on which several objects were displayed, behind a curtain in the corner of the room, and an open bag that the guests were invited to examine containing a length of rope, a squeaking doll rattle, and a large tambourine. They also examined the medium himself, with two men in attendance perfectly suited for the job – David Williams, the chief constable of Cardiff, and his deputy. They were so thorough in their search that the ladies waited outside

as the medium's clothes were removed. When everyone was satisfied the policemen then used the rope to tie the medium's arms to the chair and the curtain was drawn, casting the room into darkness but with enough streetlight outside to cast a faint glow through the curtains.

The séance began with the singing of hymns. Within minutes, Will was speaking in an accent not his own, and Tom explained it was his spirit guide White Eagle. As they sang the tambourine and rattle came to life, throwing themselves on the floor before being carried around the circle by 'unseen hands'. The rattle passed the curtain, allowing them to see that it was 'suspended in motion' and not carried by a human hand. They began to feel something rubbing against their knees, which proved to be a guitar 'sliding about'. The medium asked 'Is Lady Dove cold?' Lady Dove replied that she was 'a bit shivery', and he assured her that 'Oh, you'll be warm soon,' and something landed on her lap. At the end of the séance she discovered it was the holland jacket that the medium had been wearing while tied to his chair. The singing continued, as did the levitating items, and at one point four musical instruments were playing at the same time. After roughly half an hour the activity reached its crescendo when the what-not began moving and discarding objects around the room and the séance finished. The police checked Will's hands and confirmed that the knots were as they had tied them, and nobody present 'expressed any doubt as to the genuineness of the phenomena'.

The events sparked a heated debate in the press, and the chief constable, a 'reliable witness', was the focus of much of the attention. He described the séance as an 'interesting experience' and, having gone in 'with an open mind', he still had an 'open mind'. As far as he knew there was 'no trickery or fraud', but he also admitted that he had no idea how magicians achieved similar effects on the theatre stage. Mr L. Joseph, JP, who arranged the séance, stressed they had done 'everything that was humanly possible to eliminate trickery', and saw the press coverage as a positive sign for spiritualism in the country: 'There is no doubt that Wales is beginning to wake up in the matter of spiritualism.' As for Sir Arthur? He pointed out in the *Daily Mail* that the events had done nothing but show that 'there are unquestionably powers, and intelligent powers, outside our ordinary senses', and that the whole affair was 'very elementary'.

Testing the Thomas Brothers

The Thomas brothers of Penylan found fame following their starring role in the 'famous Cardiff séance', but not everyone was as impressed as Conan Doyle. It was decided to put their powers to the test and they were offered £500, a substantial sum in early twentieth-century Britain, to 'produce a ghost' in the presence of experts in London. The brothers were unsure if their powers would work as well outside of Wales, and even questioned if White Eagle would allow them, but Tom, the elder and more 'dominant' brother, accepted the offer. They came from a deeply spiritualistic family and Tom was determined to show the world that it was genuine. Will, on the other hand, despite being a 'powerful medium', had grown up seeing spiritualism as that 'silly thing' and was happier playing football. That all changed suddenly when he found himself 'compelled by some force' to join in, and his skills quickly blossomed.

The Thomas Brothers.

He took a rather philosophical view on such tests, saying that: 'Do not resist rigorous tests. Trust the higher powers; they will do the rest. Honest scepticism is the best food for a medium.'

 With the date set, a newspaper office was chosen as the venue, a building deemed both suitable for the purposes of the experiment, and conveniently located for the all-important press coverage. They recreated the conditions of the 'famous Cardiff séance' as closely as possible, and the medium was once more 'stripped and searched' beforehand. With everything in place, Will was tied to the chair, the lights were turned off, and the séance began. As they'd hoped, 'striking phenomena' was observed which could not be easily explained, with items of clothing flying across the room from the bound medium. Other activity, however, such as moving musical instruments, was not. In this respect, it was deemed a partial success, or a partial failure, and the conditions of the experiment, such as environmental noises outside, were blamed for the disappointing results. Ultimately, while it did not prove that they could 'produce a ghost', it did, for some at least, 'create the impression that the Thomases are certainly not frauds'.

Psychic to the Stars

Lilian Bailey was a 'deep trance medium' who found fame as the medium of choice for some rather illustrious clients, which reportedly included Queen Elizabeth II. Described by the *Daily Mail* as a 'powerful, 6-foot-tall, working-class Welsh woman', she was born in 1895 in a small flat above the Grangetown Conservative Club where her parents worked as servants. A bright child but without the financial means to further her education, she instead used her initiative to shake off her humble origins. The turning point came at the age of nineteen with the outbreak of the First World War and the death of her mother, which is believed to have ignited her interest in spiritualism. Working as a secretary for the British Army in France under Sir Sydney Crookshank, Director-General of Transportation, she returned home with an OBE (Officer of the Order of the British Empire), a badge of honour that surely helped her advance up the social ladder. Remarkably, nobody thought to question this award, and when inquiries were made to the *London Gazette* in 2014 it 'was confirmed that no OBE was ever given'. The First World War also provided her with a spirit guide, a man she called William Hedley Wootton, a captain in the Grenadier Guards who had died during the conflict. It has since been claimed that 'no such soldier ever existed'. Her big break with royalty came courtesy of the speech therapist Lionel Logue, best known for helping King George VI manage his stammer. So pleased was he after Bailey contacted his recently departed wife that he became a cheerleader for her abilities, which culminated in a top-secret séance in 1953. The entire affair was done with the utmost confidentiality, and Bailey was blindfolded and driven to an unknown location in Kensington where, it is reported, the reigning monarch, along with other members of the royal family including Prince Philip, had gathered in the hopes of contacting George VI. What happened in that room remains a mystery, but it can be assumed that it wasn't considered a failure as the Queen Mother was supposedly eager to engage Bailey for another meeting. She had, it seemed, earned the royal seal of approval.

King George VI.

The Golden Age of Ghosts

The Victorian age has been described as the 'golden age' of ghosts, and this was certainly the case in Cardiff. Ghosts were everywhere in British society, from the publication of the most well-known ghost story of all, Charles Dickens's *A Christmas Carol*, to the theatre stage, where illusions such as the Pepper's Ghost allowed apparitions to magically appear before bewildered audiences. Ghosts, however, were not confined to works of fiction. The Industrial Revolution coincided with huge advances in the printed press, and the many newspapers and periodicals that spread the printed word were awash with accounts of real-life hauntings. Unlike the folkloric phantoms of old, these malicious spirits were entering people's homes and causing mayhem like never before, and the activity continued well into the Edwardian period.

The Welsh dragon on top of City Hall. (Ham, CC BY-SA 3.0)

Pesky Poltergeists

In 1847, Catherine Crowe introduced a new word to an English-speaking audience that continues to make hairs stand on end today: poltergeist. A combination of two German words, *poltern* and *Geist*, it roughly translates as noisy spirit, and allowed investigators to put a label on a specific kind of invisible apparition characterised by the fear and destruction it left in its wake. One such account involved two neighbouring houses in Riverside Street, where an occupant on one side was disturbed by strange noises that sounded like the knocking of knuckles. They assumed it was their neighbour and when the noises became a regular occurrence they decided to speak with them, only to discover they had also heard the noises and assumed the same thing. The press caught wind of the story and initially tried to dismiss the activity as the work of river rats from the nearby Taff, but when no rational explanation could be found both houses became increasingly alarmed and the case remained a mystery.

At around the same time, a house in Lisvane became the target of nightly unexplainable events that went far beyond knocking on walls – according to the reports, this poltergeist could pull people from their beds. The property was 'midway between the Parish Church and the Welsh Baptist Chapel' and home to a widow,

Illustration of a poltergeist in action from La Vie Mysterieuse, 1911.

Church of St Denys, Lisvane.
(No Swan So Fine, CC BY-SA 4.0)

three or four children, and an elderly lodger. They would regularly hear chairs being drawn about by themselves, crockery smashed into countless pieces, and lived in constant fear of being touched by unseen hands in the dark. Lying in bed one night, the lodger felt his bedclothes being pulled from him, and he hurriedly struck a light. Although he couldn't see anyone in his room, he was convinced that he was not alone and conducted a thorough search. Finally satisfied that there was no one under the bed or inside the wardrobe he returned to sleep, only for his bedclothes to be yanked away once more. Again, he could see nor hear anything moving. What became of the Lisvane poltergeist is unknown, but it was last reported that the locals were seeking expert help.

In the early twentieth century, a family living in Canton were left 'badly scared' by the noise of heavy boots stomping around their home just after midnight one Christmas; sadly, this festive visitor was not delivering presents. They had lived at the property in King's Road peacefully enough for six years when the sounds suddenly began downstairs that were loud enough to wake those sleeping upstairs.

The 'uncanny' footsteps became a regular occurrence and seemed to follow the same route around the house, from the front room to the passage and onto the stairs leading to the bedrooms. The husband was determined to find a natural cause, and his failure to do so was making his wife and children increasingly apprehensive. He tried to catch the culprit in the act by standing ready at the bedroom door, but as soon as he heard the sounds and opened it, they suddenly stopped. He then conducted a thorough search of every room as well as the exterior of the house, only for the sounds to return

The sun sets in Canton. (Jeremy Segrott, CC BY 2.0)

with added ferocity after he returned to bed. He repeated his search and the result was the same, except by this point the entire house was now awake and greatly alarmed. All non-supernatural sources, such as the gas meter, were ruled out, as was the idea that it might be a thief, because burglars needed to be quiet to be successful, and were unlikely to return to the same property nightly and steal nothing. What scared him the most was that whoever, or whatever, was causing the disturbance was presumably watching him and was aware of his movements. While the sounds were loud enough to wake the entire household the neighbours were never disturbed, and the case, as with the other accounts, remains unsolved.

The Ghosts of Greenmeadow

A grand mansion that once stood on the outskirts of Tongwynlais had a reputation for being one of Wales's 'most haunted houses'. The activity reported at Greenmeadow House spanned the centuries, and while the building has since been demolished, its name survives in Greenmeadow Drive, and aspects of the property remain in the council estate built on its grounds. Having started life as a seventeenth-century farmstead, it became the home of politician Wyndham Lewis in 1817, who dubbed it Pantgwynlais Castle and gave the façade a makeover more suiting his status. The house passed to his brother Henry following his death and remained in the Lewis family long afterwards, as did the many ghosts, which included a former servant that

Tongwynlais. (Ilya Kuzhekin, CC BY 3.0)

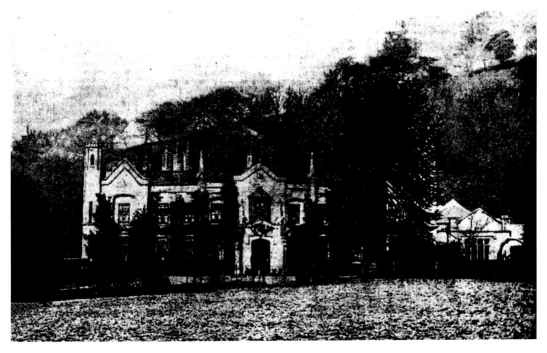

Greenmeadow, The Main Front, 1910.

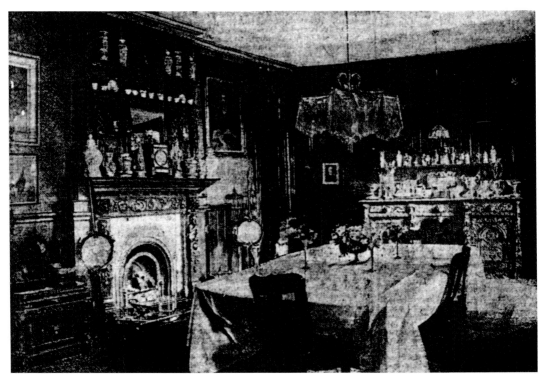

The dining room with carved overmantel and sideboard, 1910.

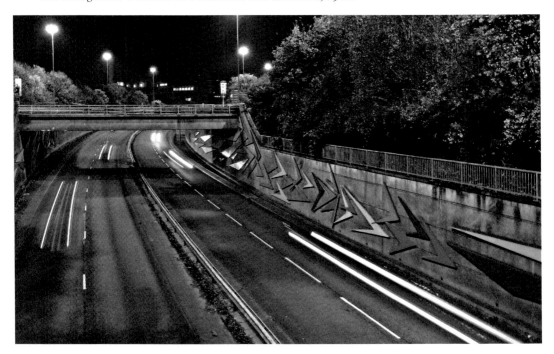

Gabalfa Interchange at night. (Jeremy Segrott, CC BY 2.0)

haunted the 'Blue Room', and a hunch-backed apparition lurking in the cellar. One tale suggests the inhabitants were cursed by a young maid called Kati Coch, so called because of her red hair. Having been seduced by a 'scamp' in 1840, he convinced her to help him loot the dining room, which included stealing a precious whistling jug, or in some accounts a silver jug. While the rogue escaped unpunished, his accomplice was caught and sentenced to hang in nearby Heath. An eyewitness to her death claims she was driven there in a cart sitting on her own coffin, and as she prepared to meet her maker, she whispered a hex on the family. She is said to have been the last woman hung at this spot, and while the exact location is unknown, the Gabalfa interchange now runs by.

In the late nineteenth century, a first-hand account of a visit to Greenmeadow was published in the press. The narrator described it as a 'pretty pale-green stucco house' that stood among such 'verdant pastures', yet when the sun set things weren't quite so idyllic. The house was in the care of Henry Lewis, who spoke of being 'startled with the footsteps' he heard there as a boy, and the servants had witnessed 'many strange figures' including 'a little man in red'. Miss Vaughan, who would housesit while the Lewises were away, was so distressed by the noises she heard coming from the 'haunted' part of the house that a strong doorway was built at the entrance. The most reported ghost was a grey lady, a 'shadowy form' of a woman 'enveloped in a shapeless film of cloudy grey' who glided along the passageways around midnight. She was mainly felt rather than seen, and sometimes heard when her high heels hit the floor, and her favourite room was a large bedroom. Henry's mother-in-law often slept in the room when visiting and she would find herself awoken by 'the alarming sensation of a form she cannot see bending caressingly over her'. Perhaps the most remarkable encounter with the grey lady comes from the lady of the house, who was showing off her home to a friend only to be left mortified when she discovered that her housekeeper had been uncharacteristically careless. They entered a room where the key had been left in a door and jars of jam were left opened, and as she tutted to herself, she suddenly felt her companion 'pass her arm round my waist and draw me affectionately towards her'. Upon turning, she was surprised to see her friend at the other side of the room from where she could not possibly have touched her. Sometime afterwards she discovered that the housekeeper had a good excuse for her tardiness that day; she was so alarmed by 'the apparition of a woman in grey' that she fled the scene without stopping to lock the door.

Earlier in the nineteenth century, Martha Moggridge from Rhiwbina visited with her bedridden sister Mabel. Mabel was staying in the 'Oak Room' and unable to sleep, so Martha agreed to read to her until she drifted off. As she did so they were disturbed by a scratching sound, but both assumed it was the cat. Eventually they fell asleep, but when Martha awoke again at 3 a.m. she noticed her sister was also wide awake and staring at the door. It slowly opened and a face peered through with 'a large prominent nose and a shock of rather white hair'. The girls, frozen in fright, could only watch as this 'small old man' in a green coat with a sash containing a rapier entered 'a yard or so from the floor' and began to tap the walls. Martha tried to ring the bell for help but it fell to the floor, and when the maid walked in at dawn their relief was immense. Martha took the opportunity to leave her sister and ran to see Henry, who laughed off the events as 'women's imagination'. But they were not the only people to encounter a strange visitor in this room. Decades later Captain Mostyn, a 'brave hero of Rourke's Drift', was also disturbed while sleeping in the 'Oak Room' by a thudding at the door. He opened his eyes to find a sword-wielding man with red hair gazing out of

the window, who suddenly crossed himself, fell to his knees and disappeared. While not exactly matching the description of the man seen by Martha, there are enough similarities to suggest a connection. This time, when Henry was told of the events, he did not dismiss them as 'women's imagination', but admitted it was a regular visitor and asked the captain to keep the experience to himself to avoid scaring the staff.

The activity was not confined to indoors, and in 1860 the musicians from the Melingriffith Band received a fright as they made their way home following a late-night gathering. They were in a merry mood as they walked along the drive when a 'fierce, foul and awful' apparition appeared and caused them to drop their instruments and flee. It was only after the sun had risen that they found the courage to return and collect them. Another eerie incident concerns a gardener called Daniel who worked for the Lewises throughout his life. There was a particular area that sacred him for some reason he never explained, and even the dogs stayed away from it. He was continuously warning the children to avoid playing nearby, saying to them: 'Indeed to goodness, keep away, will you?' It was in this very spot that Daniel's lifeless body was found one summer's day, having died from heart failure. The fact that he had died in an area he hated was strange, but even stranger was the fact that he was not alone – lying next to him were the dead bodies of some of the dogs.

By the 1930s, the estate was unoccupied and slowly falling apart. The locals complained about its condition and in 1940 a real-life tragedy occurred when part of the mansion collapsed and killed two men, including the caretaker. The house was demolished soon after and the press published memories from some of those who remembered the place before it was left to decay. Gwen Wyndham Lewis recalled her time there during the late 1800s and described it as a depressing place 'where laughter seemed out of place'. She wrote of how one night a fearsome storm brought with it an ill omen, and as they shielded inside they were disturbed by loud knocks and the doorbell ringing despite nobody being there. She reassured herself that there was some natural cause, but 'First thing next morning the message arrived informing my father had passed away.'

The area was redeveloped, and in 1974 ghostly activity was being reported once more in one of the houses on the estate. It was in the home of Suzanne Morgan and her eight children that taps were being turned on, bangs and footsteps were heard, and ash was raked from the fireplace. It soon escalated to furniture being moved, and one day an old woman appeared on the landing and said 'Julie', the name of one of the children. The frightened family refused to sleep upstairs, and when the local newspaper heard of the events they decided to investigate. Two journalists spent the night upstairs while the family remained downstairs, and the only event of note happened around 2 a.m. when the temperature dropped and a 'strange haze seemed to fill the room'. It was all over very quickly and, it should be noted, both men were smokers. A more difficult incident to explain occurred afterwards. When their roll of film was developed it came back blank, and when the camera was checked it was found to be in perfect working order.

Supernatural Splott

In the early twentieth century, it was natural rather than supernatural phenomena that was blamed for causing bizarre activity in Cardiff. Earthquakes were said to be triggering 'unusual rumblings' that moved possessions and damaged property,

View of Splott from the city centre. (Sionk, CC BY-SA 4.0)

but there were problems with this theory. Firstly, no earthquakes had been reported in the surrounding area, which made it unlikely that only a small section would be affected; and secondly, when the activity escalated to ripping up clothes and rolling carpets, suspicion soon shifted to other causes. The earthquake-like activity began in Pontcanna before moving across the city, but it was in Splott that things got extra strange. It was in the home of Mr Williams, who lived on Seymour Street with his wife and children, that the damage happened so quickly it was assumed to be the work of a frantic burglar ransacking the house. Nothing had been stolen, however, only left in a state of disarray, suggesting it was unlikely to be the work of a thief. It further emerged that the activity began before any reports of earthquakes were published, but the family, fearing that it might be paranormal in nature, had remained quiet about it.

It had started, as many such cases do, with raps being heard from the walls. It escalated when a friend visiting the house claimed that she found her clothes 'torn to shreds' by some invisible attacker, and a young relative who was writing a letter was startled to see the paper 'splitting clean in half'. She tried again, only for the same thing to repeat itself, and when she managed to finish writing a letter the stamp was 'chipped at the corner' as she attached it to the envelope. On the day of the suspected earthquake, objects were mysteriously moving around the house. Kitchen utensils were strewn across the floor, ornaments fell off the mantelpiece, and the contents of a drawer were emptied. The police were called, and the PC who investigated, according to the newspaper report, saw the cover of a teapot lift itself off the table and a glass smash. Most astonishing of all, he saw three mats roll themselves up and 'march into the dining-room', stopping one of them with his foot. The activity continued and word

soon spread that the house was haunted. These were the days when a supposedly haunted house could attract a sizeable crowd, and the police were soon back at the property not to search for ghosts but to repel would-be ghost hunters. Around 500 people gathered outside covering 100 yards of Seymour Street with some remaining until 3 a.m. The family, having had enough of both the damage to their property and the unwanted attention, fled to live with a neighbour.

A theory emerged as to the identity of the potential ghost. According to a 'gruesome story of a past horror', a woman who died in a nearby 'tragedy' was buried locally and was returning to terrify the living. A more sceptical theory proposed by scholars at the University College cast suspicion on a member of the family. They noted how Elsie, the youngest daughter, was present during most, but crucially not all, activity. A neighbour had also experienced items being moved and damaged in their home when Elsie was present, although the occupant was adamant that it could not have been caused by a human hand. When it emerged that Elsie's fingerprints had been found on some disturbed items the press was also quick to brand her the culprit, and yet if we accept the published reports as accurate then it couldn't be the case. The policeman, for example, witnessed activity while Elsie was present in the house, but fast asleep in her room. Was she cunning enough to outwit the police, or is there some other explanation? Could Elsie have even been the cause unknowingly – was something malicious working through her?

The House of Dread

In the early 1950s Elliott O'Donnell, a widely published author of fact and fiction, released a collection of tales so terrifying that readers were warned they contained 'ghostly phenomena that are physically, mentally and morally dangerous'. One such tale concerned a home in Cardiff which was described as the 'house of dread', and while no address was given, it was said to have stood empty since before the First World War when it was the home of the Webb family. The Webbs were not the superstitious kind, and while the house had a reputation for being haunted, they had experienced nothing to make them think it might be. Nothing, that is, until they were visited by Mr Moor, a friend from London, who recalled the strange events of his stay to the author on his return. It began one night as they sat in the drawing room and heard what sounded like the rap of knuckles on the door. When Mona Webb, the eldest daughter, opened the door, the gas-lit hall was empty. She could hear what sounded like footsteps running away and heading upstairs, but after searching the rooms she found nothing. Was it a prank? A few days later, Moor retired to his room and as he sat down for a smoke by the fire he suddenly leaped back out of the chair in fright – it was already occupied. Or rather, it felt like it was. He couldn't see anybody, yet he had the sensation of sitting in somebody's lap. He tried a second time, only to find the invisible sitter remained. On another occasion, when Mrs Webb was alone in the house, she heard what sounded like someone running in the same hallway her daughter had heard footsteps. This time she was quick enough to catch a glimpse of the culprit fleeing, noticing 'a bony, hairy leg disappear round a bend in the staircase'. She retreated into the room and locked the door until her husband returned.

A ghost on the stairs? (Axel Rouvin, CC BY 2.0)

Events came to a head one evening when, as they sat together after dinner, a series of 'bumps' were heard from the floor above. They opened the door and once again saw something moving in the hallway, but this time in the opposite direction – it was moving towards them. It was hard to get a good look in the shadowy hallway, but nevertheless 'it was something very extraordinary, not unlike a nude trussed body that did not seem human nor quite animal, but an unpleasant mixture of both and something else'. The family returned to the room and kept a watchful eye on the door, but nothing more happened until they retired. Waking with a start, Moor had the sensation he was not alone in the guestroom. He could hear a scurrying that edged closer and gripping his bedclothes he closed his eyes in terror. When he found the strength to open them again he saw a 'nude, revoltingly fat, shapeless figure' leaning over him and grinning. He demanded that the creature depart and, thankfully, it obeyed, vanishing into thin air. It was time for the Webbs to seek help, and a spiritualist friend recommended they do what most families did in similar situations – conduct a séance. They gathered around the breakfast table and, while things were slow to start, they escalated quickly when the table levitated into the air and crashed to the ground. The following night, Mona awoke and reached for a match but instead touched a clammy undead face and her resulting screams woke the household. This proved to be the final straw for both Moor, who left the next day, and the Webb family, who followed a fortnight later.

The Lledrith of Windsor Place

Omens are a common feature in Welsh ghost stories. Some are good, some are bad, and some, such as in this account, serve no obvious purpose other than to confuse us. A man in his sixties known as Mr K who lived in Windsor Place was spotted one day by two friends as he walked home along Queen Street, or Crockherbtown as it was at the time. They were looking to do business with Mr K and followed him, watching as he entered his house. They knocked the door and informed the servant that they wished to speak to her master but were surprised to be told he was not there. Assuming she was lying or mistaken they asked to speak to the lady of the house, who said the same thing – he was not at home. They had no choice but to leave the house and, as they did so, hardly believing their eyes, they saw Mr K once more walking along the street. They followed him along Duke Street to High Street and when he vanished from sight, they decided that rather than chase him around Cardiff the best way to speak to him would be to visit his office. Upon arrival they were told that he was in his room and would be happy to see them. They found him calmly looking over his accounts, and one of the men said: 'Well, there is no mistake about it, you have played us a fine trick.' Mr K looked bemused and, after they'd recalled their experience, he explained that he had not stepped foot outside of his office since arriving at 9 a.m. that morning and called a witness to prove it. The men were convinced that they had seen him on several occasions and, if it had not been Mr K in person, it must surely have been his

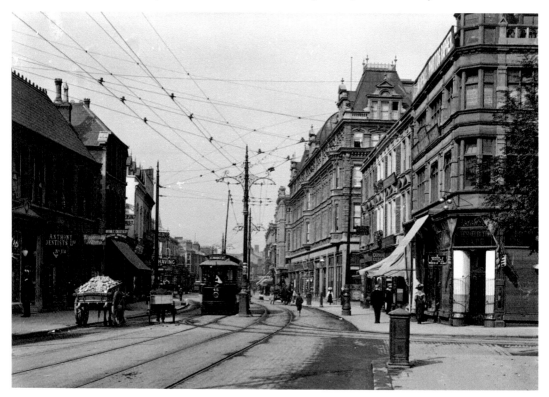

Queen Street *c.* 1905, by Martin Ridley.

High Street, where Mr K 'disappeared'. (Peter Morgan, CC BY 2.0)

ghost, but they had no idea as to its significance. Unlike the death omens featured in this book, it did not signify his imminent demise or anything similar. Rather, Mr K lived a long and happy life, during which he was fond of telling people his anecdote about the 'Welsh Lledrith' – an 'unaccountable happening'.

The Woman in White

In 1897, a reporter visited a house in Roath after unexplainable knockings had forced a family to flee. He would later admit that he arrived at the scene a sceptical man, but by the end was left 'baffled and mystified'. A few months earlier, the family had rented a recently built house on Montgomery Street to be near the stable that was a stone's throw from the Recreation Ground. After the disturbances they hastily relocated, but only to the opposite side of the street so they could retain the stable. The man of the house, described as a sincere man, appeared to be the main target of the 'spirit', although all members of the household had some experience with it. They had moved in during the autumn and all was well to begin with, but his sons soon started hearing 'rapping' in their shared room at night, seemingly coming from the clothes box. The father told them it was their imagination, and even after hearing it himself gave it little thought, until the noises started on the door of his own bedroom. Assuming it was one of his children he tried to catch them in the act but found nobody there, and his daughters would soon be the first to not only hear but see something. One morning

Roath Brook in Roath Park Recreation Ground. (No Swan So Fine, CC BY-SA 4.0)

A Roath landmark: the postbox and the tree on nearby Ninian Road. (Jeremy Segrott, CC BY 2.0)

at around 2 a.m. they were awoken by sounds when they saw a shadow moving across the wall. The activity continued for weeks with doors opening and closing and clothing being tugged, and on one occasion as the man walked upstairs he had an experience that froze his blood: something suddenly 'passed' through him.

Most nights the man would stable up the horses between 11 p.m. and midnight, and if he was indisposed other members of the family would help. He often heard what he described as footsteps walking along the roof of the stable and, as with the bedroom door, he tried to catch the culprit but there was never anyone there and nowhere for them to escape to. It was on Boxing Day when, after a long day, the eldest son saw his father sleeping in front of the fire. The twenty-four-year-old decided to do a good deed and see to the horses, but the man was only resting his eyes and followed his son soon after. When he arrived at the stable, he found him frozen in fear having seen something on the way: a face. A face that belonged to a woman dressed in white who then glided towards the house and vanished as she hit the shed. The son, as with the father, had also been an unbeliever beforehand. Soon after the family moved out, and the details of the haunting were published in the press. As a result, a previous tenant got in touch who also claimed to have been scared by 'strange tappings'. On the other hand, another former resident said they had no problems at all. The property's landlord, unsurprisingly, dismissed the reports as 'humbug'.

Llandaff by Night

At the heart of Llandaff, the 'Cathedral city within a city', stands one of Wales's oldest places of Christian worship. The glorious Llandaff Cathedral is a much-renovated twelfth-century masterpiece of Gothic architecture that was established on the site of an even older church. It is also the scene of many local tales, with spectral figures lurking in the shadows at night, hiding among the trees and playing in the graveyard. Cathedral Close, the road that runs alongside the cathedral, is ominously known as 'the road of the dead', but not necessarily for any paranormal reasons. It is said the road was once the path to an old cemetery on the banks of the River Taff, and that bodies would have been transported along it. The spirits of children are claimed to haunt the route, and it has been suggested they might have been the victims of a cholera outbreak in the nineteenth century. While there was a devastating outbreak in Victorian Cardiff, it is unknown if any of those who died were buried in this location. Nowadays, Llandaff is equally well-known as the birthplace of Roald Dahl, who was born at Villa Marie, Fairwater Road. A blue plaque can be found on the former sweetshop where the boy who grew up to write many a scary story for children and adults alike would buy his gobstoppers. Llandaff is also recognised for preserving traditions, and folklorist have written of how at Christmastime the cathedral would be decked out in evergreens while the Mari Lwyd, a festive wassailing tradition in which a horse's skull challenges households to a game of rhyme and song, persisted longer than in other areas.

A mysterious bell, much like a death omen, would toll at midnight on the night before the death of someone in the parish. A more terrifying death omen is the Gwrach y Rhibyn, a folkloric witch-like figure known as the 'hag of the mist' in English which shares some similarities with the Irish banshee. Described as an old

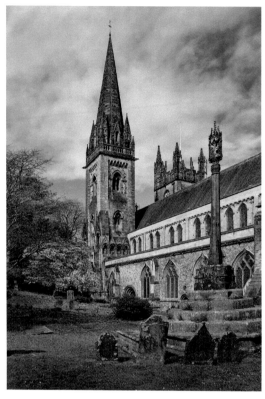

Llandaff Cathedral. (Richard Williams, CC BY-ND 2.0)

Llandaff Cathedral. (Peter Broster, CC BY 2.0)

Llandaff Cemetery. (Mark Healey, CC BY-SA 2.0)

City Cross, The Green, Llandaff. (Dave Snowden, CC BY-SA 2.0)

A gargoyle watches on in Llandaff. (Tom Sens, CC BY-ND 2.0)

woman who more resembles a leather-winged harpy than anything human, she flies around the streets at night, peering through windows and terrifying the inmates by screeching the names of those doomed to die. For a first-hand account we can turn to a 'respectable-looking man of the peasant-farmer class' who was staying with a friend one autumn night in the late nineteenth century. He was rudely awakened by a 'frightful screeching and a shaking' at the window which, like a gust of wind, was suddenly gone. The man was more excited than frightened and rushed to open the window where he saw the Gwrach looking back at him as she continued her flight. He described her as a 'horrible old woman with long red hair and a face like chalk, and great teeth like tusks' who was wearing 'a long black gown trailing along the ground below her arms'. He watched as she flapped her wings against the window of a house below, before heading for another property, and this time she entered the door and did not re-emerge; it was the Cow and Snuffers Inn. The next day he recalled that 'they told me the man who kept the Cow and Snuffers Inn was dead—had died in the night. His name was Llewellyn... he had kept the inn there for seventy years, and his family before him for three hundred years, just at that very spot.' He believed the family's long lineage was the reason they were targeted: 'It's not these new families that the Gwrach y Rhibyn ever troubles, sir, it's the old stock.'

A landlady of another pub which has long since been demolished is said to haunt the streets and banks of the nearby river. Known as Bella, it was after finding God that she turned her back on the drinking and debauchery that took place under her roof and, following a heated argument with her husband, fled in despair. She headed

Llandaff Meadow. (Alexey Komarov, CC BY 2.0)

past the cathedral and down to the water where she threw herself in and her ghost, seemingly unable to find the peace in death she sought in life, is seen and heard running the same route. Another ghostly woman also said to be trapped because of a watery tragedy visits the area near the Choristers Hall where her son, possibly dressed in blue, was lost in an accident. His body was never found, and his distraught mother frantically searched along the river in vain, worrying herself into an early grave as a result. Her hunt continues to this day, in the cathedral's grounds and the banks of the river, and she is occasionally seen wading into the water. Finally, a pub with more recent supposed paranormal activity is the Maltsters Arms where in 1965 the landlord Ken Perrett was one of the witnesses who claimed to see a 'small, dark man who wandered the bars at night'.

Terrors of the Taff

The River Taff is a folklore-filled body of water that starts life as two rivers in Bannau Brycheiniog before converging in Merthyr Tydfil and winding its way out into Cardiff Bay. Home to many species of animals and fish, along with the salmon and eels are some rather more curious inhabitants, the most unusual of which is the so-called frog woman. First encountered on the road between Llandaff and Cardiff, she was said to be part human and part frog and moved like an amphibian with an unmistakable croak. Only seen on moonlit nights, it was believed that, much like a werewolf and

River Taff in the shadow of Llandaff Cathedral. (Richard Williams, CC BY-ND 2.0)

River Taff. (Jeremy Segrott, CC BY 2.0)

The River Taff flows out towards Cardiff Bay. (Karen Roe, CC BY 2.0)

other creatures that combine characteristics from more than one species, she was either born that way or had the ability to transform. Another rumour suggests that she is more of a spirit than a shapeshifter, having been the unwanted child of a well-to-do family who sent their 'dirty secret' away to live with a labourer near Llandaff. One day she fell into the river and, unable to get out, her ghost now screams for help to escape the dark waters.

In times gone by, a whirlpool named one of the 'Seven Wonders of Glamorgan' would form on the River Taff at Cardiff when the bed was almost dry. A sight to behold, this bottomless whirlpool was home to a 'monstrous serpent' that lurked in its cavernous depths. It would lie in wait ready to devour anyone who found themselves drifting into its orbit, and those who fell in would never be seen again. Few drowned bodies were ever retrieved from the water, but on the occasions they were discovered it was said that the victim must have been 'very good' for the serpent was unable to eat the righteous. According to one 'old woman' the serpent wasn't the only deadly creature lurking in the whirlpool. It was also frequented by a beautiful woman who used her looks to lure young men towards her. Oblivious to the danger, they were sucked into the vortex and never seen again. This lady, she claimed, was the devil in disguise, or at least working in his service, for the pool was a pathway that led from the Taff to the mouth of hell where 'Satan waits for the souls who are beguiled by the lovely lady.'

Modern-day Nightmares

Accounts of ghosts are not limited to ivy-covered castles and Victorian séance rooms. Tales of paranormal activity are reported across the city to this day, and while the ways in which we consume them might have changed, with online videos favoured over the daily newspaper, the public's enthusiasm remains undiminished. For some people it might be a form of escapism, for others it's the more serious matter of finding evidence of life after death, but whatever your motivation, in the twenty-first century the streets of Cardiff contain several places where the dead, it is said, do not rest easy. In this final chapter we'll explore some of the supernatural cases which have been reported in living memory, starting with possibly Cardiff's most widely reported haunting.

Cardiff City Hall by night. (Tom Sens, CC BY-ND 2.0)

Pete the Poltergeist

In the 1980s, Cardiff was the scene of 'one of the biggest poltergeist cases ever'. The activity continued for more than a decade and was witnessed by members of staff and the public alike. It was reported in the press, investigated by paranormal professionals, and in 1994 the case was reconstructed for the Michael Aspel-fronted ITV show *Strange but True?*. The poltergeist was even given a suitably Welsh nickname: Pete the Polt.

The events took place in Cardiff Mower Services, a lawnmower repair shop with adjoining garden accessories shop, in an alley off Crwys Road. Established by John Matthews in 1978 with his wife Pat and her brother Fred Cook, it was while watching a rugby match in the workshop one Saturday afternoon that the activity began. They heard stones hitting the roof which they assumed was a childish prank, but when they went outside there was nobody there. The stones continued to fall and the police were eventually called but there was still no sign of any trickery. It was only when similar events started happening inside the shop that they suspected 'something strange' was going on. Stones, coins and bolts were thrown across the room, objects of 'unknown origin' such as old coins from 1912 appeared on surfaces and fell from above, and they even found paper money pinned to the ceiling. A lot of the activity appeared to be centred around a particular 'active corner' of the shop, which Pat noticed turned 'ice cold' with a 'terrible smell of burning'. Paranormal or otherwise, somebody or something was toying with them, and John and Fred decided to test two theories at once by conducting a séance. They still didn't think it was paranormal, but by gathering everyone together for a séance they could then rule them out as suspects, and who knows, they might even contact a ghost. They locked the doors, linked fingertips

A view of Crwys Road. (Elizabeth McGuire, CC BY-SA 2.0)

Bolts and screws were thrown around the garage. (frankieleon, CC BY 2.0)

Cathays Methodist Church. (Ceridwen, CC BY-SA 2.0)

on a workbench, and called out to any spirits who might be listening, challenging them to throw a stone at them. The spirit obliged. Then John said that they should be recording the activity, and with that a pen was thrown at him. It appeared to be listening and providing them with what they wanted, and when John asked for engine parts they were also thrown down. After two hours, they seemingly all had the proof they needed that it was a poltergeist.

Unlike similar cases in which the living are terrorised by their uninvited guest, the family were not afraid of the poltergeist. In fact, they named 'him' Pete and he 'became part of the family'. They did, however, want some answers, and sought professional help from David Fontana, Professor of Psychology at Cardiff University, and future president of the SPR. His thorough investigation lasted more than two years between 1989 and 1992, after which he published a detailed report. He visited sporadically and unannounced to catch any would-be tricksters off-guard, and on his first visit a stone flew past with a 'ping' as he opened the workshop door. John turned and said: 'There you are, he's welcoming you.' Fontana was 'fortunate enough to witness many of the phenomena' for himself, noting that it was 'rare for an investigator to be there when things actually happen'. In his report he recorded how the poltergeist possessed both 'intent and the rudimentary intelligence', and that its 'responsive' nature allowed it to play simple games and act on prompts. For example, if he threw a stone into the 'active corner', the stone would be returned. Then he noticed something even stranger; it wasn't the same stone being returned but a different stone, which ruled out any chance of it somehow bouncing back. He wrote of how missiles were rarely seen flying but rather appeared to 'materialise' just before hitting the ground, and interviewed several witnesses he considered to be 'honest'. He even visited the business when the family were on holiday so he could dismiss the unlikely possibility that they were the cause. In conclusion, while he could not rule out that it was an 'elaborate joke', having thoroughly checked the premises for accomplices, potential mechanical devices, and after dismissing any environmental factors, he concluded there was 'a definite intelligence involved'.

The poltergeist activity was not confined to the workshop, or even the premises. The shop was sandwiched between two churches, and Revd Mike Fuller from the Baptist church, whose office overlooked the workshop, said that: 'Before I knew anyone else had problems, one evening I was working up here in the office and stones started hitting the window. I did everything I could to find out what it was, there were no people down there.' If this was Pete up to his old tricks in a different location, it should be noted that in all these accounts he never hurt anybody. He was considered more childlike than malicious, and even when objects were thrown directly at people, they were thrown lightly. He is even thought to have tried to be helpful at times, such as laying out the cutlery for breakfast. A clue to his identity emerged one day when Fred believes Pete materialised before him. He recalled how he was fixing a mower with John when he looked up and saw 'a tiny boy' on the shelf waving at him: 'He was all grey – no face, but the face was there – it's hard to explain.' Fred warned John not to make any sudden movements and to look behind him, but John saw nothing. Fred, however, was convinced that he'd seen Pete, and he would see him on at least three more occasions. Offering another potential clue to Peter's identity, Fontana recorded how John had told him that a young boy was rumoured to have been killed in a nearby traffic accident. Following the publicity of the haunting, he

was 'approached by the young boy's elder brother, now an adult, who confirmed the death and wondered whether there might be a connection with the haunting.' While Fontana found no evidence to confirm this, it remained a possibility.

When the company relocated to larger premises, Pete did not go with them and was last seen waving goodbye. He did, however, follow Fred home, or so Fred believed, who said there were 'countless' incidents in his house such as spoons being thrown up the stairs. When Fred and his wife moved home themselves they were advised by a medium that, as a precaution, they should break any items that Pete might have a connection with. They decided to smash a piece of pottery that would continually disappear and reappear, and it seemed to do the trick with no activity reported in their new house. Cardiff Motor Services have relocated a number of times since these events and are now under new ownership.

The Automobile Association

In 1986, reports emerged of a haunting at the offices of the Automobile Association, better known today by the initials AA. The motoring association were then based in Cathedral Road, Pontcanna, and, if the accounts are to be believed, the building, along with an adjoining flat, were something of a paranormal hotspot. Despite an office manager insisting in the local press that 'there's nothing to it', many of those working there believed otherwise. The most oft-sighted spirit was a young lady they

Cathedral Road, Pontcanna. (John Lord, CC BY-SA 2.0)

named Alice, who appeared wearing a dishevelled dress with her hair tied back in a bun and old-fashioned headphones. If anyone caught sight of her she would flash them a beaming grin before dematerialising. Some considered this smile to be a sign of friendliness, while others deemed it to be more sinister in intent. Even those who didn't see her might be aware of her presence due to the unpleasant smell that accompanied her. Another female spirit spotted on the top floor of the building was dressed in a white nun's habit, and a possible explanation is that the building might once have been part of a convent. Workers on the late shifts would hear noises coming from the empty upper rooms she was said to occupy, and the next morning they would find chairs that had been neatly stacked in a state of disarray. The haunting was even more pronounced in the flat, where poltergeist-like activity began with objects being moved and doors slammed, before escalating to chairs being thrown through the air. The final straw came when one of the occupants, the wife of a road manager who was home alone, reached out to turn up the heating when a spectral hand appeared alongside hers. She fled in fear. Another less-terrifying apparition said to haunt the flat was a white cat who didn't need a cat flap to walk through doors.

Cardiff Royal Infirmary

Cardiff Royal Infirmary has been described as the 'UK's most haunted hospital', and it has certainly seen its fair share of suffering over the years. Having started life as Cardiff Dispensary in 1822, the grand Victorian hospital on Newport Road played a crucial role in the care and well-being of casualties during the First World War when it was requisitioned for use by the Royal Army Medical Corps. It remained the city's main hospital until 1973 and emergency unit until the end of the century. Following considerable renovation work it is now cared for by Cardiff and Vale University Health Board, and it was ahead of a partial demolition in 2009 that members of staff spoke with the local press about their experiences. Douglas Bragg, a plumber from Roath who admitted to being a sceptic and yet had no explanation for what happened, heard footsteps while working in an old ward. He turned to find nobody behind him and returned to his work, only to feel a hand on his shoulder. He turned once more to see a figure at the end of the ward dressed in a grey uniform. He assumed it was the matron Eileen Reese, but something didn't feel right. He felt the urge to look once more, and when he did so she was gone. He later discovered that Reese was on holiday that week and said that: 'My only explanation to myself was that it was a ghost, but I don't believe in ghosts.'

Security officer Gareth Radcliffe from Pentwyn spoke of how most people who worked there for some time experienced something strange and was himself grabbed on the ankle by an unseen hand. Staff would feel a presence nearby, the sensation of being touched, and one 6-foot man he described as 'a big boy' was knocked from his feet by something whizzing past. He said the main corridor was haunted by three ghosts who are believed to be a soldier who fought in Mametz during the First World War, an old lady, and the grey lady who, he says, you should never accept a drink from or you'll 'be dead within a week'. He also recalled how earlier in the 2000s the pathology department were so spooked by something that they called the police and asked for an exorcism, which was performed by Father Roy Doxsey from nearby

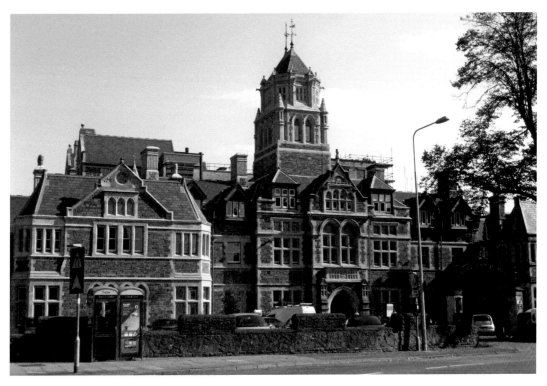

Cardiff Royal Infirmary. (Ham, CC BY-SA 3.0)

Gates at the entrance to Cardiff Royal Infirmary. (Steve Chapple, CC BY-SA 2.0)

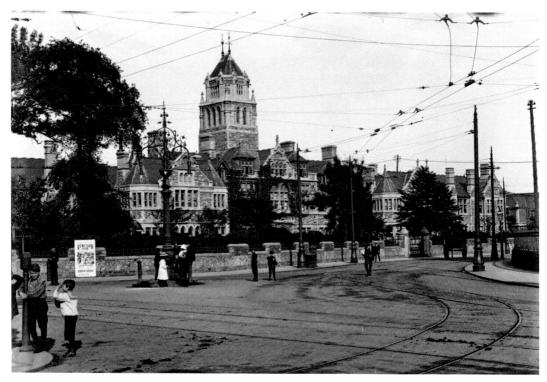

Cardiff Infirmary *c.* 1905, by Martin Ridley.

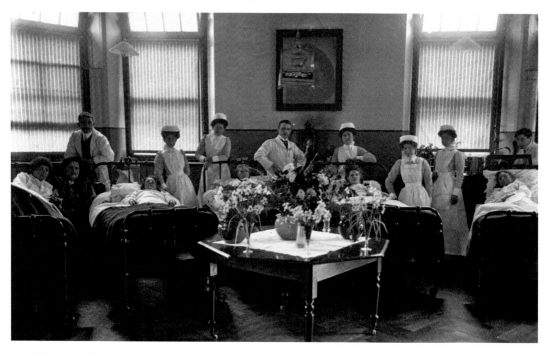

The Gwendoline Ward *c.* 1905, by Martin Ridley.

St German's Church. As Radcliffe said: 'For them to work in pathology and not to want to go back up there they've got to have seen something pretty terrible.'

Fellow security officer Gareth Owen from Pontypridd had his own strange experience while monitoring the security cameras. He noticed a figure on the screen walking into the security office just yards from him and, roughly ten minutes later, walking back out again. To reach the office they would need to walk in front of Owen, yet he only saw them on camera. Equally unusual, he described this figure as a smartly dressed woman from a bygone age, but the only security officer on duty was a man. This woman is believed to have been the same grey lady seen by other witnesses, and former clerical officer Elizabeth Bragg had a theory as to her identity. A large portrait once hung in the main corridor of a sister tending to a soldier injured possibly during the Crimean War. She is wearing a bonnet, cape, and white starched apron, which fits the description of some of the sightings. Bragg did not think the grey lady was to be feared, and to see her might even be a good thing. She recalled that: 'As you walked in, there was this glorious feeling, and she was just our grey lady and anyone who's seen her I think has had a blessing. As long as the infirmary exists, she will be there because of the way she cared.'

New Theatre

Cardiff's New Theatre opened its doors in 1906 and welcomed the likes of Anna Pavlova and Laurel and Hardy to the capital. A traditional Grade II listed theatre with a distinguished history, it has played a pivotal role in Welsh culture over the decades, staging the Welsh premiere of Dylan Thomas' *Under Milk Wood* in 1956 and housing

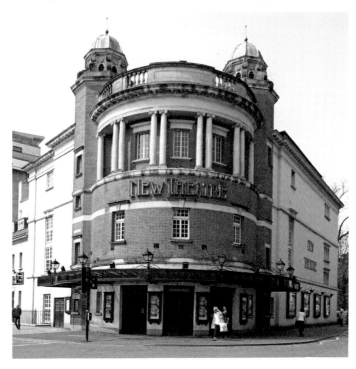

New Theatre. (Tony Hisgett, CC BY 2.0)

Welsh National Opera for fifty of their formative years. It also has a rich supernatural history, and one of the longest-reported spirits believed to haunt the auditorium is an 'old woman' who died after watching a performance in one of the boxes. She has been seen making her way to the stalls below, and some have suggested this is where she died having plummeted from her seat above. In the early 1990s, Russell Gascoigne wrote of how then stage manager Bob Bunkell recalled that an electrician nearly suffered a similar fate. He was balanced precariously in the top circle positioning a spotlight when a pair of hands caught hold of his legs and saved him from falling. When he turned to thank his saviour there was nobody there. Bunkell also experienced many phenomena himself, such as doors opening of their own accord, sudden icy chills on hot days, and having the feeling of being in the company of a 'presence'. He did, however, point out that all these events took place before the renovation of 1988, which seemingly put an end to the activity. In other paranormal cases the opposite is true, and renovation work can often disturb, not silence, the resident ghosts. More recent sightings suggest that theatregoers, especially those using the boxes, might be wise to keep their eyes peeled.

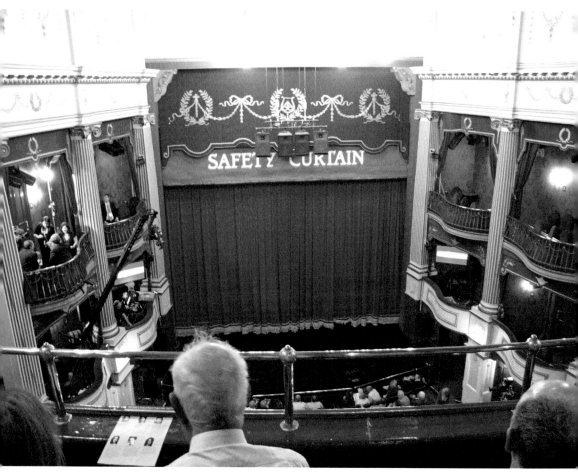

Inside the New Theatre. (Aunt Agatha, CC BY-SA 2.0)

Watching from the boxes at New Theatre. (wardyboy400, CC BY 2.0)

The Cursed Changing Room

In 1999, the Millennium Stadium, currently named the Principality Stadium, hosted its first major international match in which the Welsh rugby team beat South Africa 29-19. The country's largest stadium has many claims to fame, such as being the first stadium outside of England to host the FA Cup final, but there was one claim to fame it was keen to put an end to – it was 'cursed'. More specifically, the south changing room was supposedly cursed because of a series of increasingly unlikely coincidences. Every team stationed in the 'room of doom' ahead of a major game would lose, and with Wembley Stadium, the headquarters of English football, closed for refurbishment, it saw some of the biggest teams fall foul of the 'curse'. Arsenal lost, Tottenham lost, and Chelsea lost, despite wearing their 'lucky' white socks. Something had to be done, and management turned to the most unlikely of sources – a painter. Following attempts to remove the 'bad spirits' using such techniques as Feng Shui blessings and even walking a horse around the pitch, it was suggested that a bright mural might do the trick. Port Talbot-born Andrew Vicari, who at the time was said to be 'Britain's richest living painter' due to the demand for his work in the Middle East, offered his services. Acting as an artist-cum-exorcist, he painted a striking 7-foot scene of fiery reds, oranges, and yellows, in a which a blazing sun rises behind a galloping horse and a soaring phoenix. After the mural was finished, the next team to be stationed in the room was Stoke City, who faced Brentford in the 2002 Division Two play-off final. By this point there had been eleven straight losses for teams in the room which, according to the Stoke Sentinel, was a 'sequence that had odds of about 8,000/1'. Anyone betting on a twelfth straight loss, however, was about to lose their money. Stoke won the game 2-0.

Principality Stadium. (Ben Salter, CC BY 2.0)

The River Taff alongside the Principality Stadium. (Richard Williams, CC BY-ND 2.0)

Andrew Vicari's mural. (Mark Healey, CC BY-SA 2.0)

Vicari's art had done the trick and the curse was broken. The stadium's chairman was quite pragmatic when talking to the BBC afterwards, saying that while he was 'delighted' it was over, much like tossing a coin, 'it had to end sometime.'

National Museum Wales

National Museum Wales is the collective name of some of Wales's best-loved museums, two of which can be found in Cardiff. The jewel in the crown of the city is National Museum Cardiff, which stands tall overlooking Cathays Park. The building exudes authority with its stately façade and Greek columns, behind which are a vast collection of artistic and archaeological wonders. Yet for all its splendour, the building was originally conceived to be even grander still by architects Arnold Dunbar Smith and Cecil Claude Brewer, who won a competition to design the building in 1910. The fact that the finished museum is only a condensed version of their original vision might explain why one half of the design team are now said to haunt the halls of their masterpiece. Smith played a pivotal role in winning the commission thanks to his concept of providing reserve space on the outside of the galleries, and so attached was he to the building that, so the story goes, his ashes were concealed inside a casket and buried within the museum. Renovation work eventually meant that his ashes were disturbed and relocated, and now he rests uneasily near the public toilets. Supposed paranormal activity at the museum at the end of the twentieth century which may

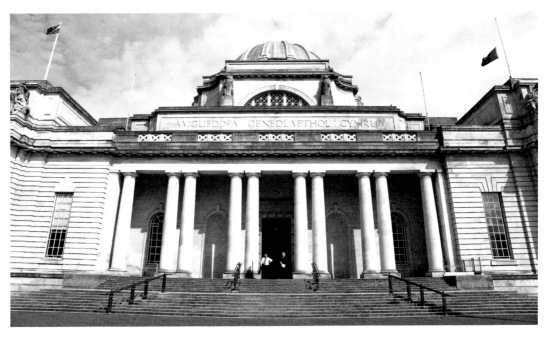

National Museum Cardiff. (Senedd Cymru, CC BY 2.0)

Detail on the door at National Museum Cardiff. (No Swan So Fine, CC BY-SA 4.0)

Statues outside National Museum Cardiff. (Elduendesuarez, CC BY-SA 3.0)

or may not have any connection with his unhappy spirit includes tampering with electrical equipment, moving objects after dark and using chairs as obstacles to trip up security. In one case a guard, having newly checked the gallery in the archaeology section for stragglers, turned back one last time and saw a tall, thin man dressed in black looking into a display case before disappearing.

Another member of the National Museum Wales family has the potential to be one of Wales's, if not the world's, most haunted places. St Fagans National Museum of History, which was named the UK's Museum of the Year in 2019, houses more than forty historical buildings which have been carefully relocated brick by brick from across the country. Spanning centuries of Welsh history, they have been reassembled in the grounds surrounding St Fagans Castle, a sixteenth-century manor house and the 'most haunted' part of the museum. They range from a former local pub that might still be serving spirits today, to a Gower farmhouse painted blood red to protect it from witchcraft. Some paranormal researchers believe that ghosts are attached to the buildings themselves, with the so-called 'stone tape' theory suggesting that past events might be captured in the stones and played back like a video tape. If this is indeed the case, then an argument could be made that, by relocating dozens of properties that have borne witness to thousands of years of Welsh history into a single place, a lot of spirits might have been relocated with them. Strange sights and sounds reported at the museum include phantom children, sudden temperature drops, shadowy figures, and ethereal voices that call the names of the unsuspecting. Then there's the folkloric apparitions like the phantom funerals (*toili*) and corpse candles, death omens said

St Fagans Castle gardens. (Michel Curi, CC BY 2.0)

St Fagans. (Scouse Smurf, CC BY-ND 2.0)

Autumn sunset in St Fagans National Museum of History. (Mari Gordon, CC BY 2.0)

A Welsh Halloween jack-o'-lantern carved from a swede at St Fagans. (Mark Rees)

to emerge from Pen-rhiw Chapel, a Unitarian meeting place dating from 1777. The museum also stands just south of the sight of the Battle of St Fagans, a bloody battle fought during the English Civil War of 1648 in which more than 200 men were killed and, according to lore, caused the River Ely to run red with blood. The sounds of battle are still heard on quiet nights, and legend also speaks of a seriously injured soldier seen fleeing towards St Mary's Church where the waters of the holy well were said to magically heal wounds. He arrived too late, and now haunts the area.

You Are Now Leaving Cardiff

Finally, to end our investigation into the ghosts of Cardiff, here's a curious tale of a phantom that was looking to leave the city. It was on a dark winter's night in 1985 that a man noticed a girl hitchhiking on the side of the road as he drove westward. These were the days when hitchhikers were a more frequent sight, and the carriageway was a common spot to see them after a visit to the capital. The rain was torrential, and visibility was so low he could barely make out her form in the downpour, and the kind-hearted man naturally stopped to offer a lift. She gratefully hopped in and explained that she was heading in the general direction of Neath. He described her

The M4 in and out of Cardiff. (N. Chadwick, CC BY-SA 2.0)

as having light hair with freckles and considered her to be a perfectly normal young lady. As they made polite conversation the girl, who had a faint stammer, mentioned that she was from Briton Ferry, and while the driver didn't know the area that well, he insisted on making a detour to ensure she arrived home safely on such a terrible night. Having dropped her off at her doorstep he watched as she dashed inside before driving off.

The next morning, as the good Samaritan set off for work, he noticed that his passenger had left a memento behind – her yellow rain-hat. He returned to the house at the end of the day and, upon knocking, a woman answered the door who he assumed to be the girl's mother. She took one look at the hat in the man's hand and burst into a scream, falling backwards in a near faint. Her husband stormed into the hall and, upon seeing the item of clothing, was equally incensed and threatened to call the police over this 'sick joke'. The man hurriedly explained the events of the night before and it was only when he described the girl that the husband began to calm down. With a dejected air he invited the man inside and explained that a year previously, on the same date, his daughter had been hitchhiking home on the same road in Cardiff, but she was not driven back safely to her doorstep – she was killed. When she was buried her favourite hat was buried with her, the very hat the man was holding.

While the tale has the air of an urban legend about it, the local historian Alun Evans who recorded it received assurances that it came direct from the family and felt certain elements of it were genuine. There was just one a problem; he found similar versions of the tale elsewhere in the world and concluded that the story might be a 'related myth' – that is, a story that began life as a true story in one place and has since influenced similar tales in other locations. Could that mean that a phantom hitchhiker really does haunt this stretch of Cardiff road, but the finer details of the story might have been embellished by similar accounts? Maybe the only way to solve this mystery is to keep a look-out for a yellow rain-hat when you head west from Cardiff on dark stormy nights.

Bibliography

Badcock, J., *Welsh Legends: A Collection of Popular Oral Tales* (J. Badcock, 1802)

Barber, Chris, *Ghosts of Wales* (John Jones, 1979)

Books, J. A., *Ghosts & Legends of Wales* (Jarrold Colour Publications, 1987)

Coxe, Antony D. Hippisley, *Haunted Britain* (Book Club Associates, 1975)

Davies, Jonathan Ceredig, *Folk-lore of West and Mid-Wales* (The 'Welsh Gazette' offices, 1911)

Evans, Alun and Willis, Williams, *Ghosts and Legends of the Vale of Neath* (Neath Abbey, 1987)

Fontana, David, *Is There an Afterlife?* (O Books, 2005)

Gascoigne, Russell, *The Haunting of Glamorgan and Gwent* (Gwasg Carreg Gwalch, 1993)

Goodrich-Freer, A., and John, Marquess of Bute, K.T., eds., *The Alleged Haunting of B—House* (George Redway, 1899)

Hall, Mr. and Mrs. S. C., *The Book of South Wales, the Wye, and the Coast* (Arthur Hall, Virtue, and Co., 1861)

Hallam, Jack, *The Ghosts' Who's Who* (David & Charles Inc., 1977)

Jones, Edmund, *The Appearance of Evil: Apparitions of Spirits in Wales* (University of Wales Press, 2003)

Jones, Richard, *Haunted Britain and Ireland* (New Holland, 2003)

Journal of the Society of Psychical Research Volume IX 1899–1900 (The Society's Rooms, 1900)

Lockley, Steve, *Ghosts of South Wales* (Countryside Books, 1996)

Moseley, Sydney A., *An Amazing Séance and an Exposure* (SLM & Co., 1919)

Nicholas, Alvin, *Supernatural Wales* (Amberley Publishing, 2013)

O'Donnell, Elliott, *Dangerous Ghosts* (London, 1955).

Parry-Jones, D., *Welsh Legends and Fairy Lore* (B. T. Batsford Ltd, 1953)

Parsons, Ian, *Swansea's Grand* (Bryngold Books, 2010)

Poole, Keith B., *Britain's Haunted Heritage* (Robert Hale Ltd, 1988)

Rees, Mark, *Ghosts of Wales: Accounts from the Victorian Archives* (The History Press, 2017)

Rees, Mark, *Paranormal Wales* (Amberley Publishing, 2020)

Sikes, Wirt, *British Goblins* (EP Publishing Limited, 1973)

Thomas, Thomas Henry, *Some Folk-lore of South Wales* (Cardiff Naturalists' Society, 1904)

Underwood, Peter, *Ghosts of Wales* (C. Davies (Publishers) Ltd, 1978)
Wilkins, Charles, *Tales and Sketches of Wales* (Daniel Owen and Company, 1879)

Other resources:
bbc.co.uk
britishmuseum.org
dailymail.co.uk
London Gazette
museum.wales
stokesentinel.co.uk
walesonline.com
Western Mail

Acknowledgements

A huge *diolch o galon* to my family for their continued support, and to Nick Grant and all at Amberley Publishing for commissioning the book you now hold in your hands. *Paranormal Cardiff* would not have been possible without the invaluable research of the many ghost hunters and folklorists who treaded a similar path before me, and the photographers who are credited throughout. I would also like to thank the following for joining me on the journey: CJ Romer and all at ASSAP, Lionel and Patricia Fanthorpe, Ronnie Kerswell-O'Hara, Cymru Paranormal, Lesley and Simon at The Bay, Simon at The Comix Shoppe, Rod Lloyd, Gayle Marsh, Jenny White, and you, dear reader, for daring to pick up this terrifying tome.

Mist on Roath Park playing field. (Gareth James, CC BY-SA 2.0)

About the Author

For more than fifteen years, Mark Rees has published articles about the arts in some of Wales's best-selling newspapers and magazines. His roles have included arts editor and what's on editor for the *South Wales Evening Post*, *Carmarthen Journal*, *Llanelli Star* and *Swansea Life*. He has written a number of books, with those of a supernatural nature including *Ghosts of Wales: Accounts from the Victorian Archives* (2017), *The A-Z of Curious Wales* (2019), and *Paranormal Wales* (2020). In 2017 he launched the now-annual 'Ghosts of Wales – Live!' event, and in 2018 *Phantoms*, a play based on his ghost stories, was adapted for the stage by Fluellen Theatre Group.

Mark Rees. (Photograph by Gayle Marsh)